Manet/Monet/Degas

HARCOURT BRACE JOVANOVICH MASTERS OF ART SERIES

Harcourt Brace Jovanovich, Inc. ⊞ *New York*

Text and design by the staff of Tokyo International Publishers, Ltd.

Copyright © 1967 by Kawade Shobō and The Zauho Press
English translation copyright © 1971 by Tokyo International Publishers, Ltd.

ISBN 0–15–156850–2
Library of Congress Catalog Card Number: 72–161096
Printed in Japan

CONTENTS

Color Plates 1
The Dawn of Visual Perception 82
Notes on Color Plates 1–76 97
Chronology 118
List of Color Plates 121
List of Illustrations 123

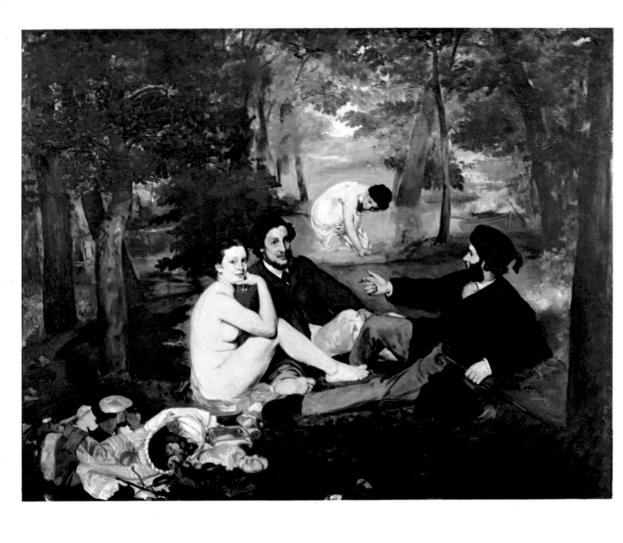

2 Manet *Le Déjeuner sur l'Herbe* (*Luncheon on the Grass*) 1863 Louvre Paris

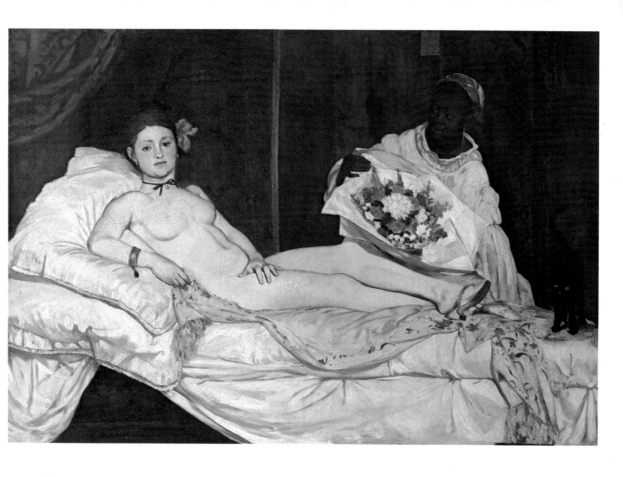

3 Manet *Olympia* 1863 Louvre Paris

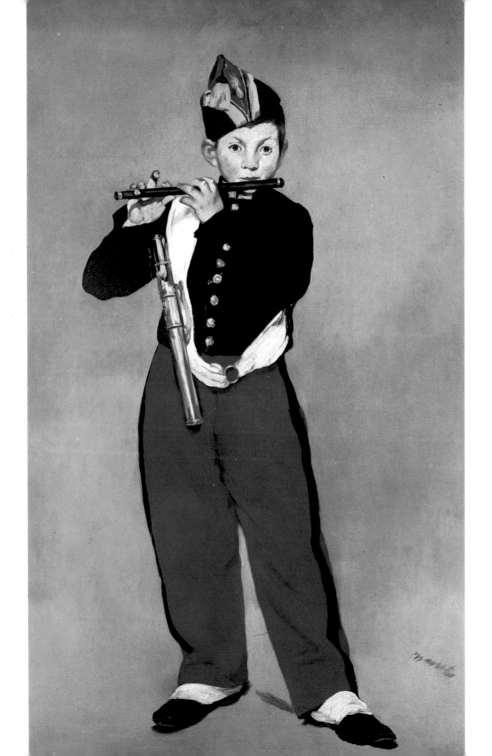

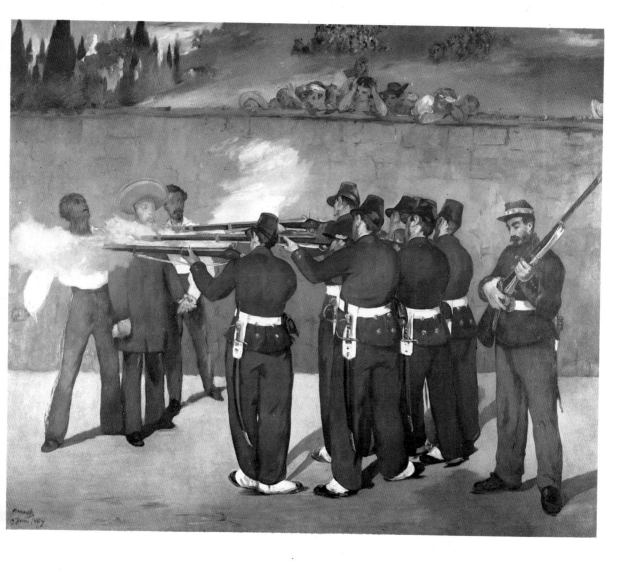

5 Manet *The Execution of Emperor Maximilian* 1867 National Museum of Art Mannheim
Manet *The Fifer* 1866 Louvre Paris

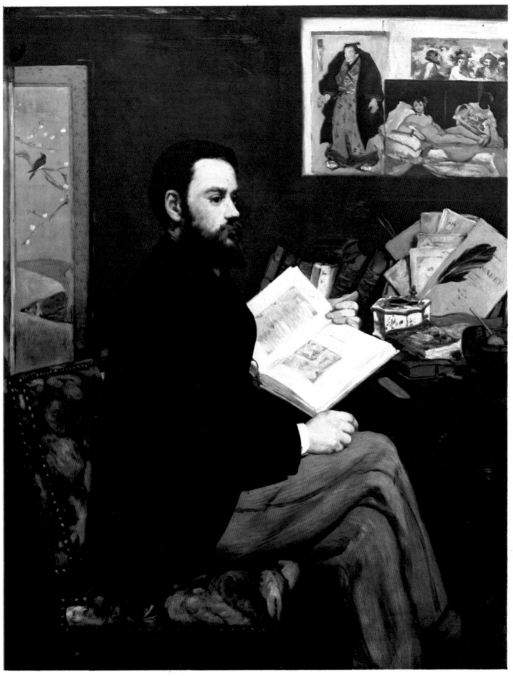

6 Manet *Portrait of Émile Zola* 1868 Louvre Paris

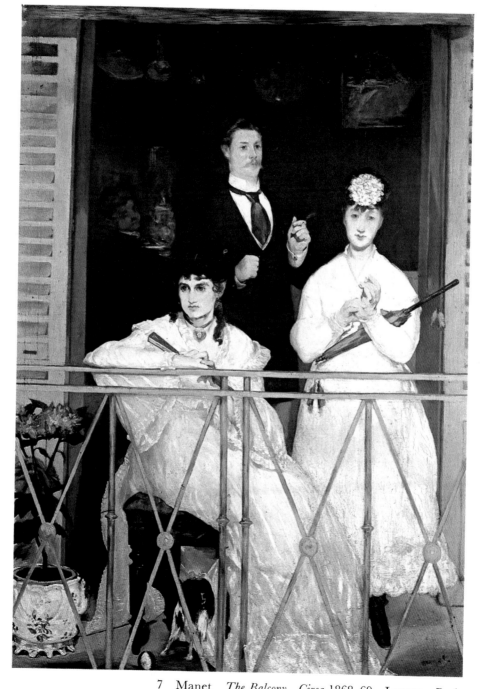

7 Manet *The Balcony* *Circa* 1868–69 Louvre Paris

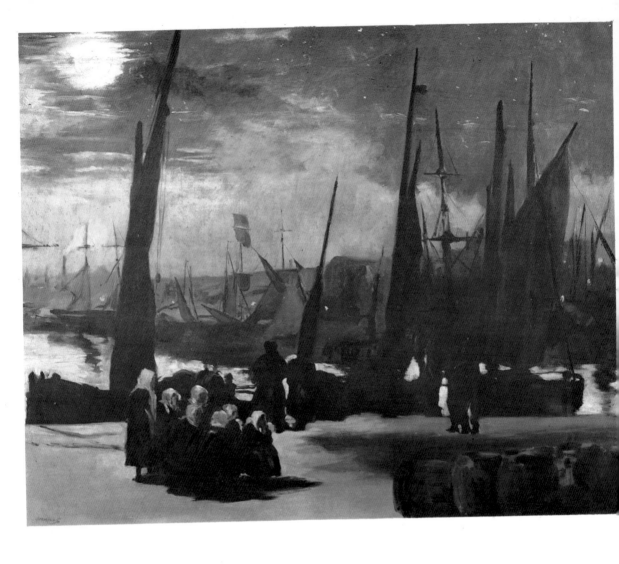

8 Manet *Port of Boulogne by Moonlight* 1869 Louvre Paris

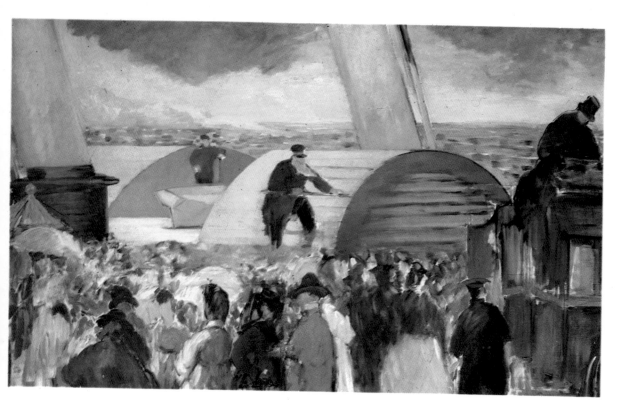

9 Manet *The Departure of the Folkestone Boat* 1869 Oscar Reinhardt Collection Winterthur, Switzerland

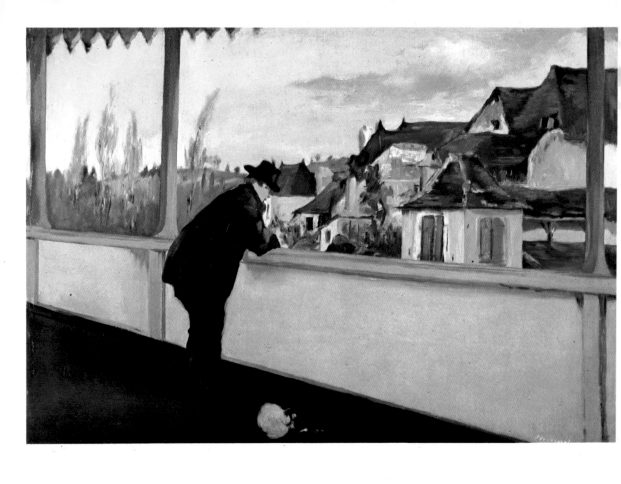

10 Manet *On the Balcony of Columns at Oloron* 1871 Bührle Collection Zürich

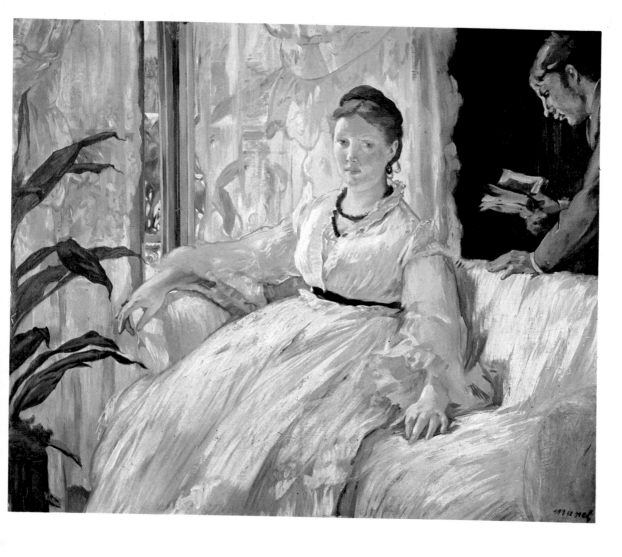

11 Manet *Reading* 1868 Louvre Paris

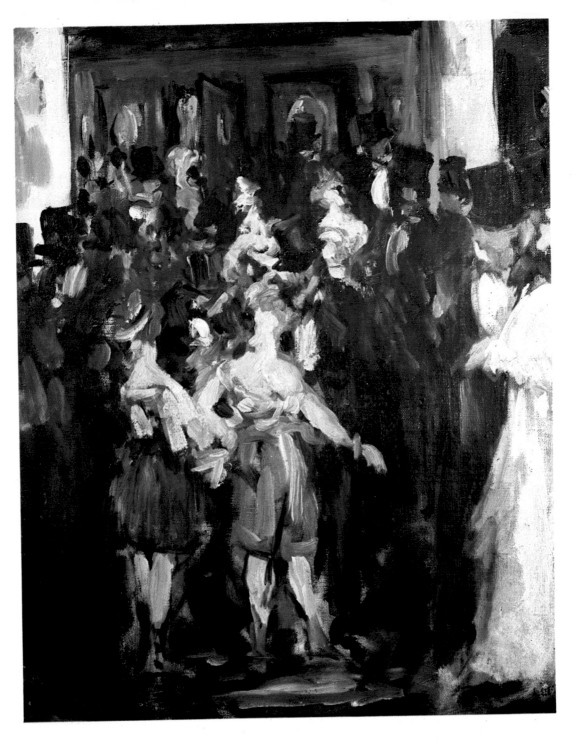

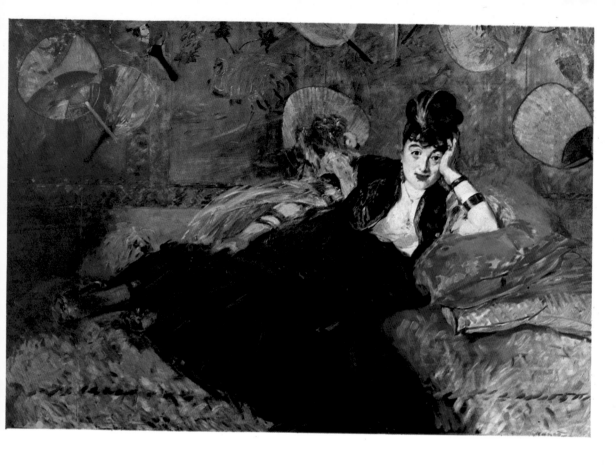

13　Manet　*Lady with a Fan*　1874　Louvre　Paris

2　Manet　*Masqued Ball at the Opera*　1873　Bridgestone Museum of Art　Tokyo

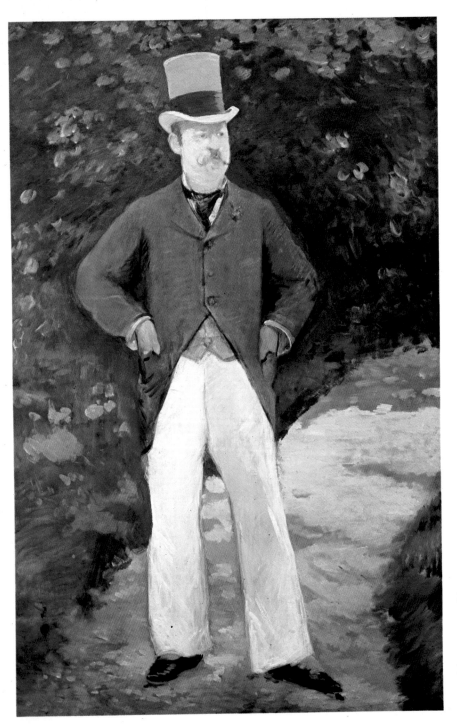

14 Manet *Portrait of Monsieur Brun* 1879 Bridgestone Museum of Art Tokyo

15 Manet *Argenteuil* 1874 Musée des Beaux-Arts Tournai, Belgium

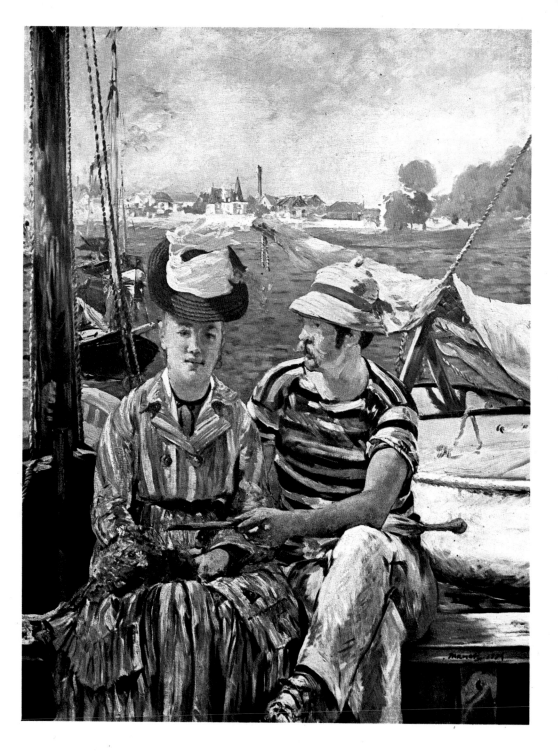

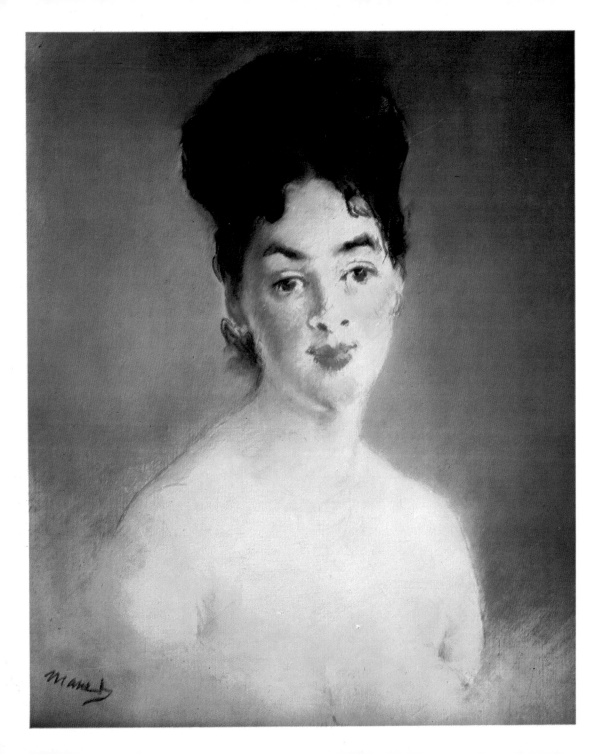

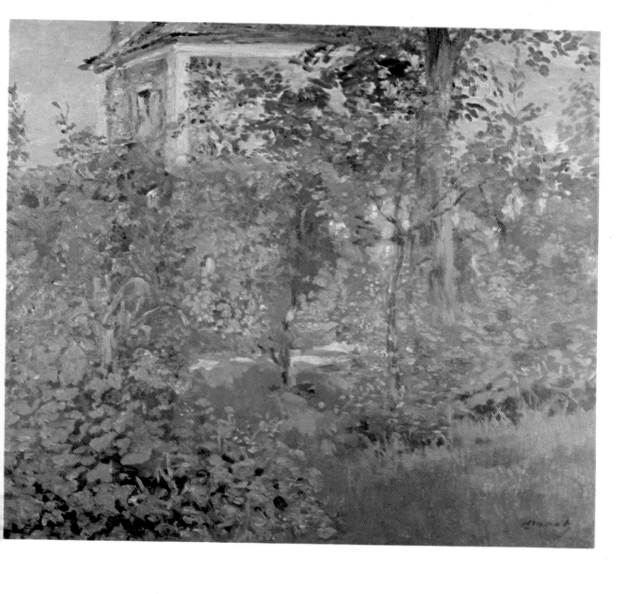

17 Manet *Garden Corner at Bellevue* 1880 Private Collection Paris

6 Manet *Bust of a Nude Woman* 1880 Louvre Paris

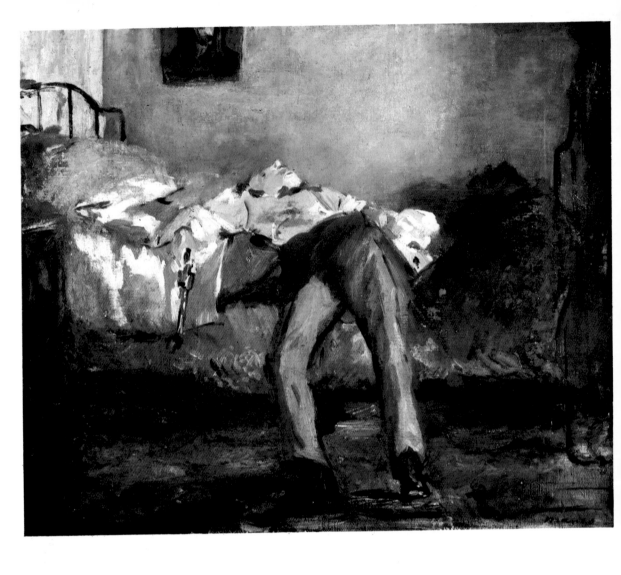

18 Manet *The Suicide* 1881 Bührle Collection Zürich

19 Manet *Carnations and Vine in a Crystal Vase* 1882 Louvre Pari

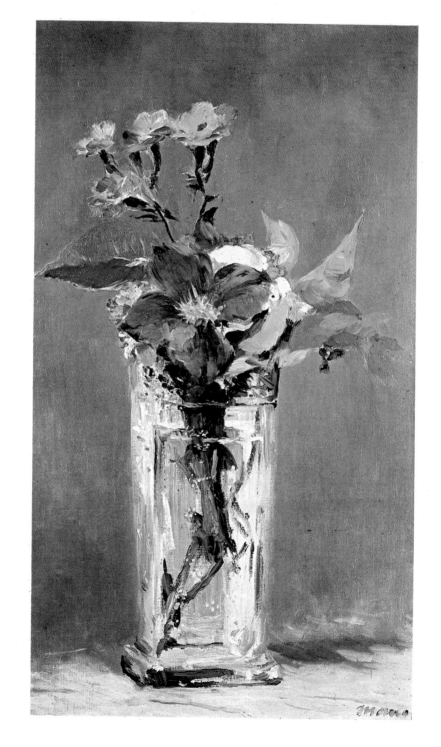

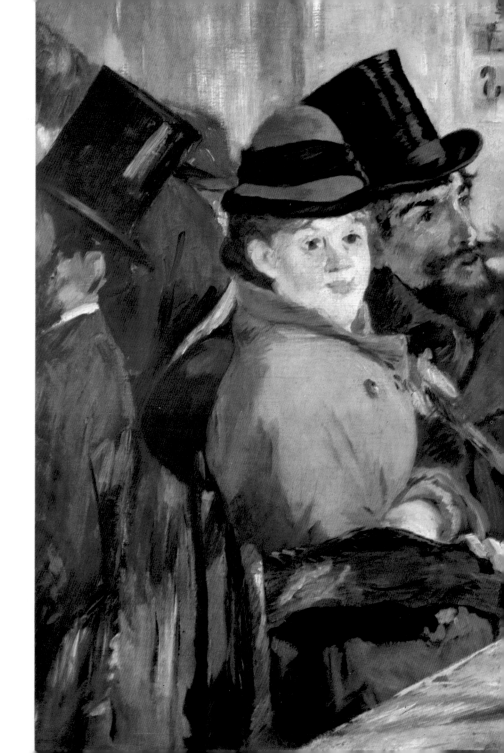

21 Manet *The Barmaid of the Folies-Bergère Bar* 1881
Musée des Beaux-Arts Dijon

20 Manet *The Café* 1878 Oscar Reinhardt Collection
Winterthur, Switzerland

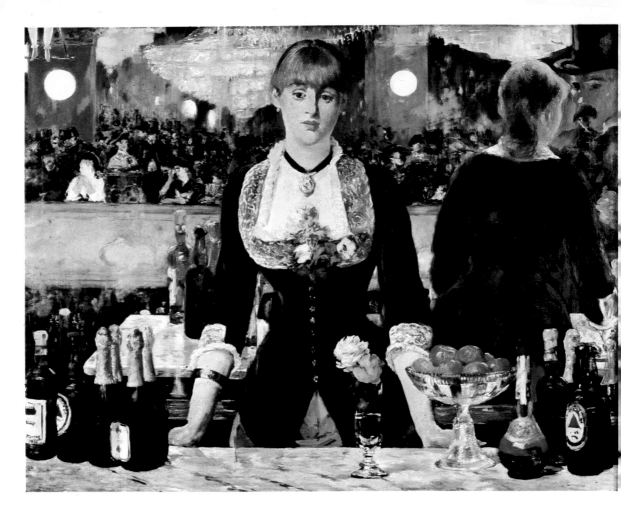

22 Manet *The Bar at the Folies-Bergère* 1882 Samuel Courtauld Collection London
 23 Manet *Corner of the Garden at Rueil* 1882–83 Musée des Beaux-Arts Dijon

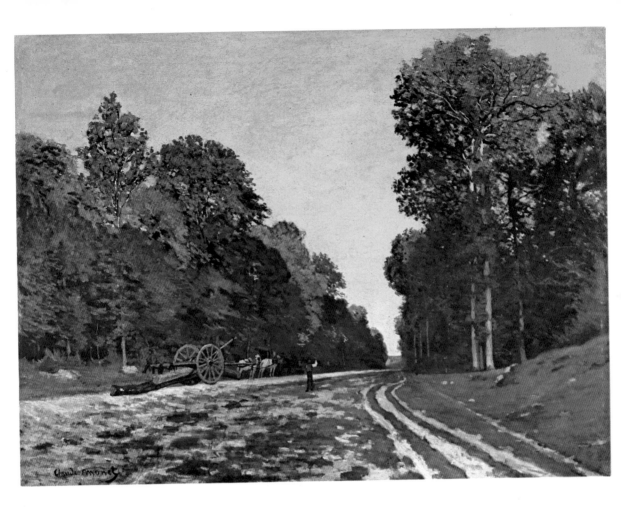

24 Monet *The Road from Chailly to Fontainebleau* 1865 Private Collection

25 Monet *Garden in Bloom* *Circa* 1866 Louvre Pari

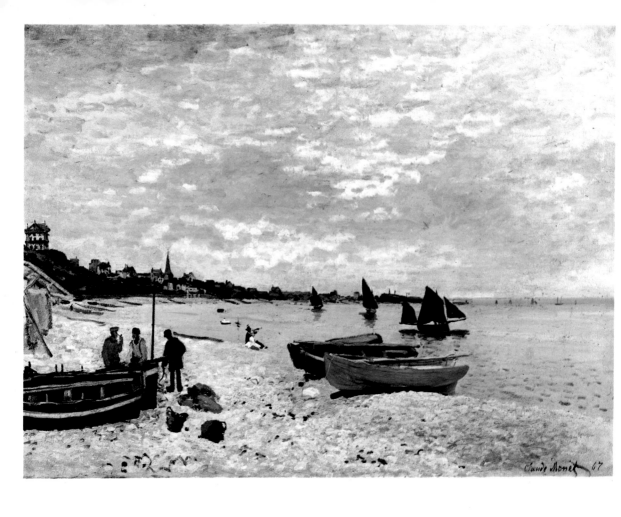

26 Monet *At the Seaside* 1867 Art Institute Chicago

27 Monet *Women in the Garden* 1866–67 Louvre Paris

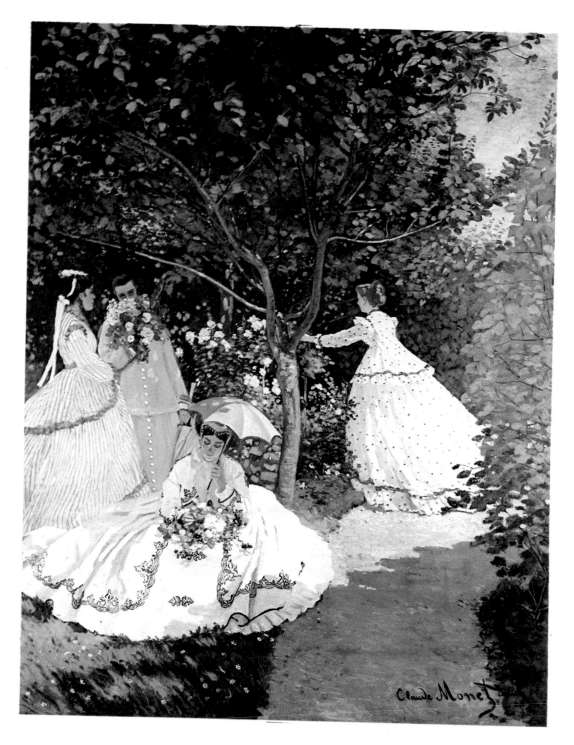

Claude Monet

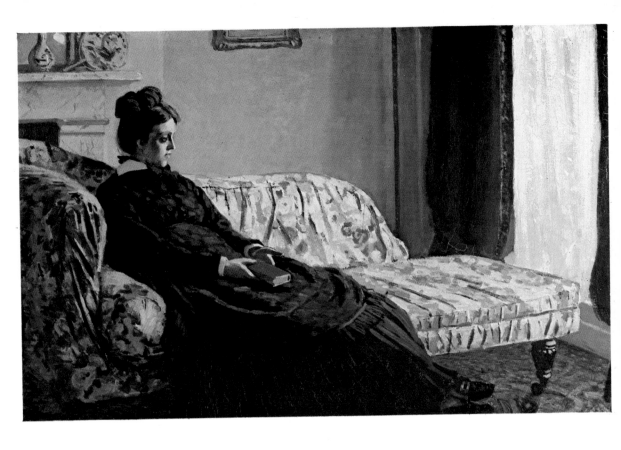

28 Monet *Portrait of Madame Monet Circa* 1871 Louvre Paris

29 Monet *Portrait of Madame Gaudibert* 1868 Louvre Pari

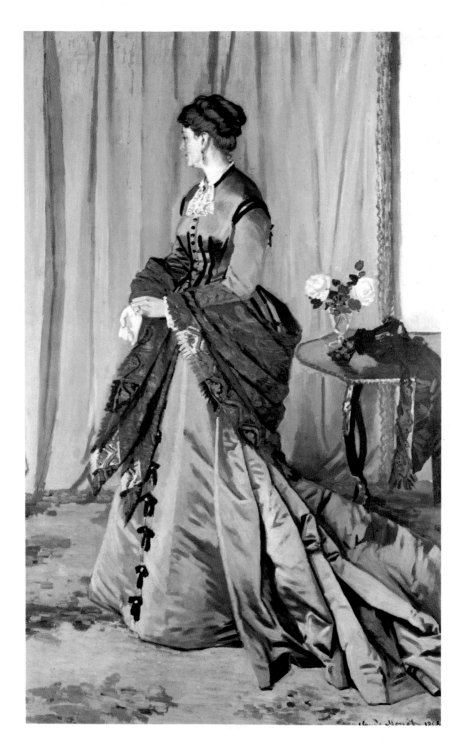

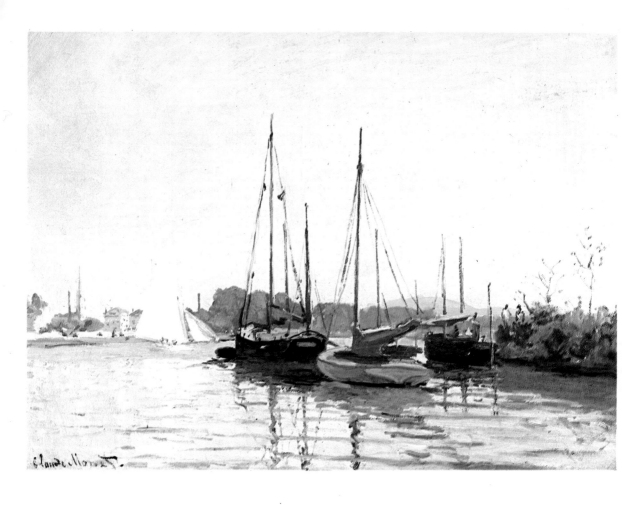

30 Monet *Pleasure Boats* *Circa* 1873 Louvre Paris

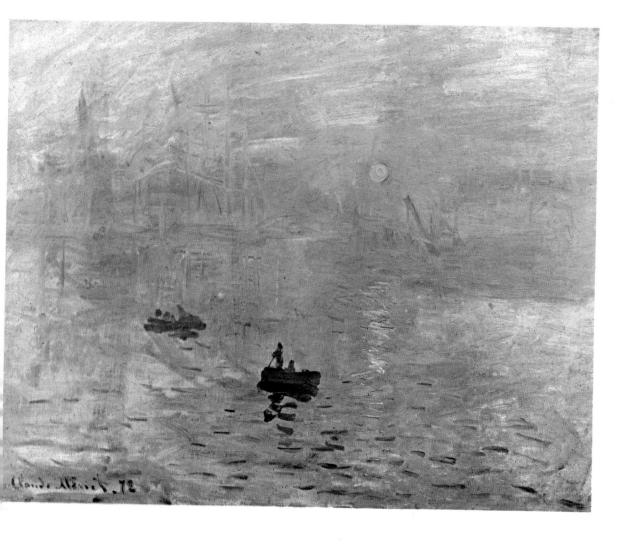

31 Monet *Impression, Sunrise* 1872 Marmottan Museum of Art Paris

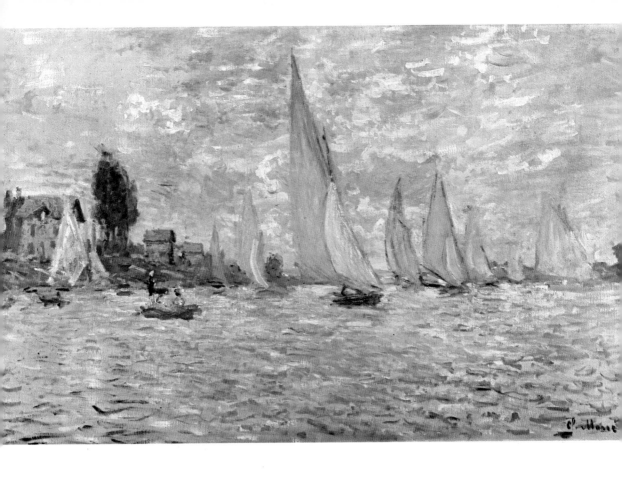

32 Monet *Yachts, Regatta at Argenteuil* 1874 Louvre Paris

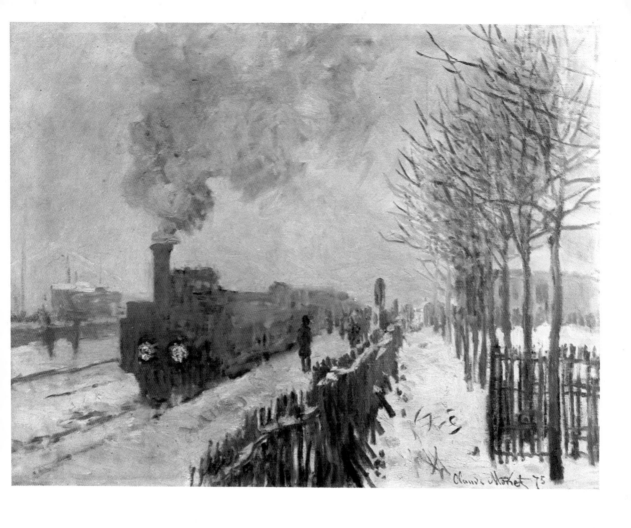

33 Monet *The Train in the Snow* 1875 Marmottan Museum of Art Paris

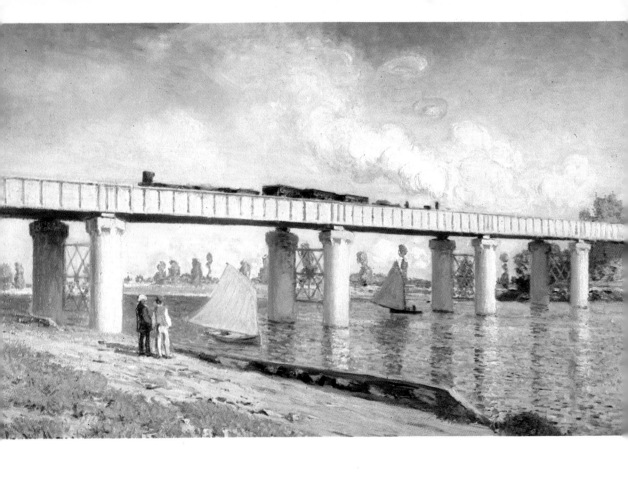

34 Monet *Railway Bridge at Argenteuil* 1875 Philadelphia Museum of Art

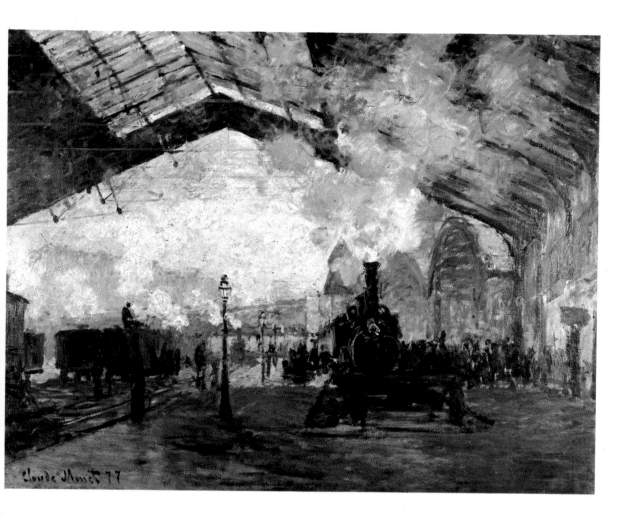

35 Monet *Old Saint-Lazare Station* 1877 Art Institute Chicago

36 Monet *The Needle Arch
at Etretat* 1890 Private
Collection Paris

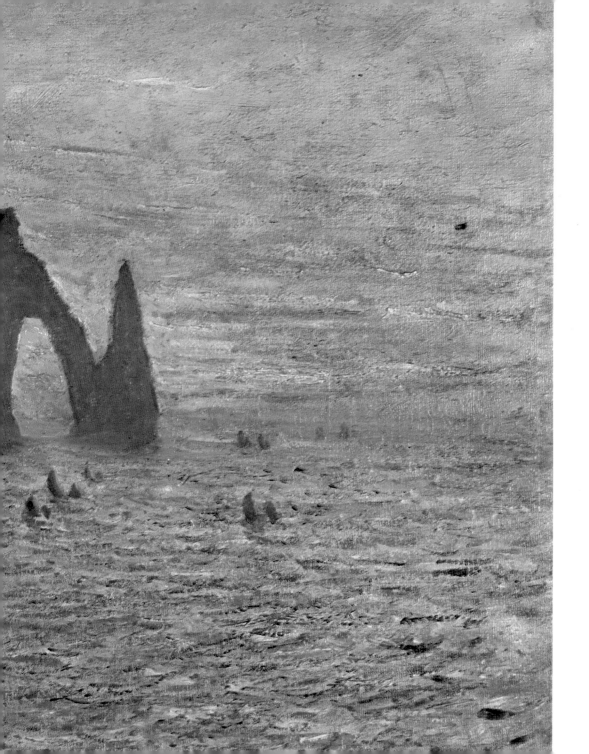

37　Monet　*The Seine at Vétheuil*　1879　Louvre　Paris

38　Monet　*Rue Montorgueil Decked with Flags*　1878　Musée des Beaux-Arts　Rouen

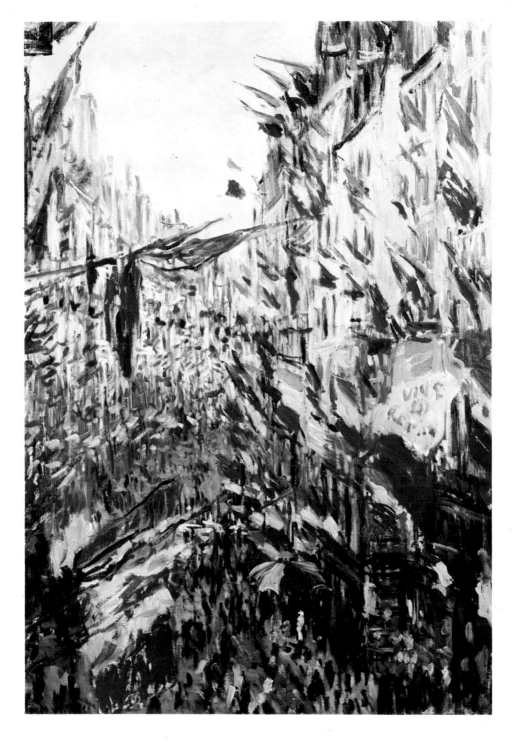

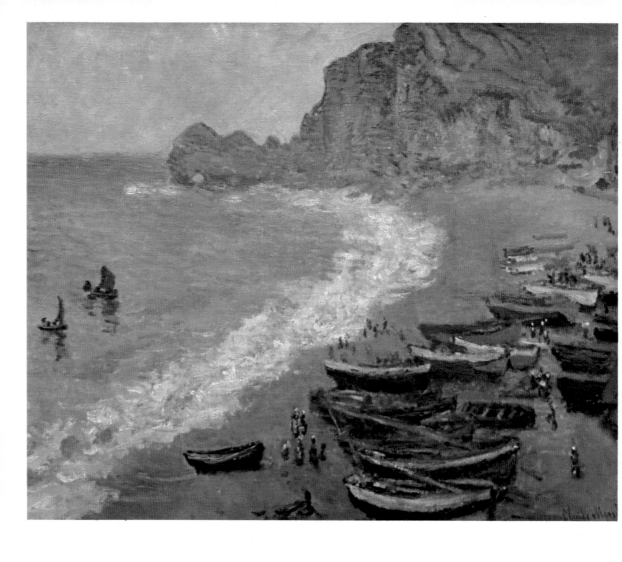

39 Monet *The Sea at Etretat* 1883 Louvre Paris

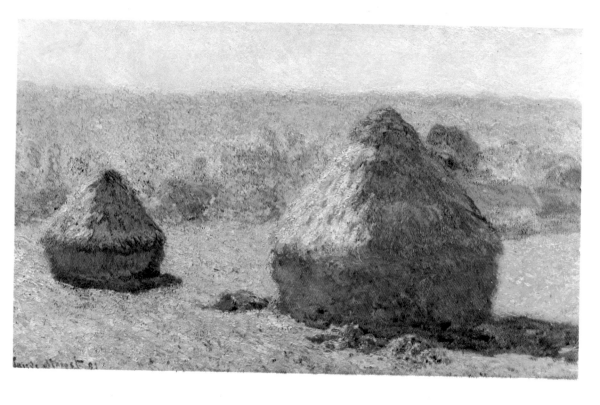

40 Monet *Haystacks, End of Summer* 1891 Private Collection Paris

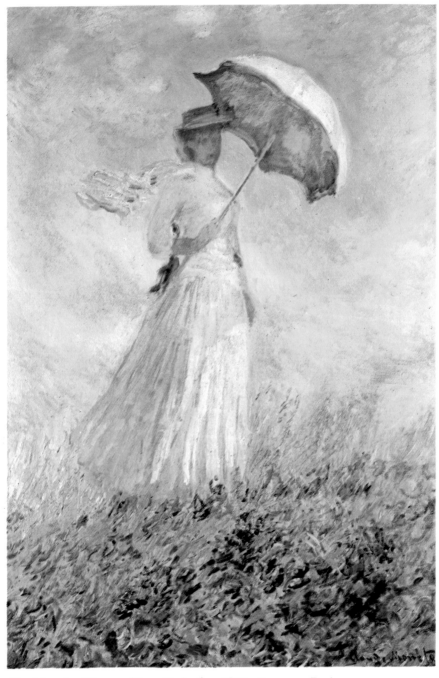

41　Monet　*Woman with an Umbrella*　1886　Louvre　Paris

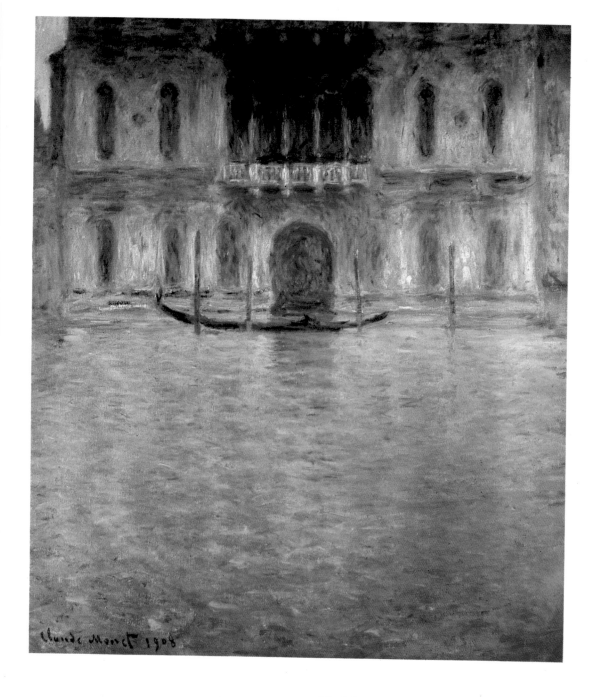

46 Monet *Venice, the Contarini Palace* 1908

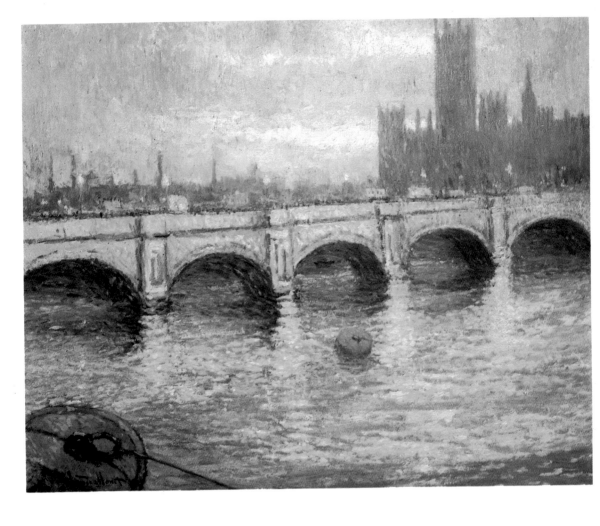

47 Monet *Westminster Bridge* 1900

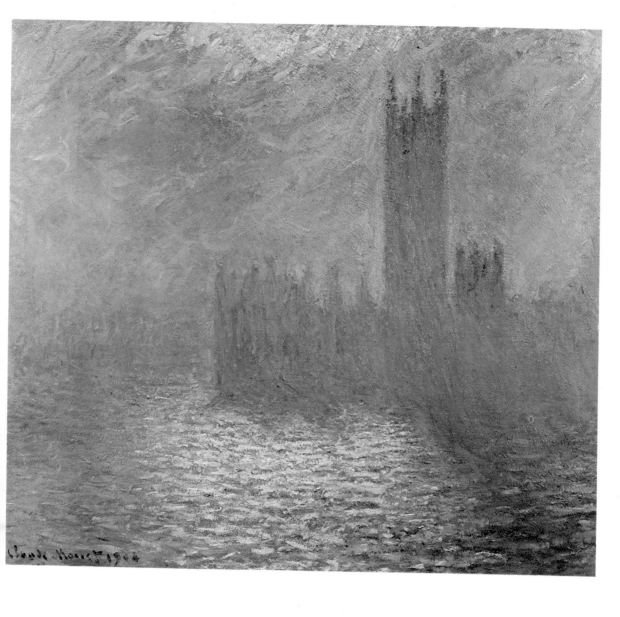

48 Monet *The Parliament of London* 1904 Durand-Ruel Collection Paris

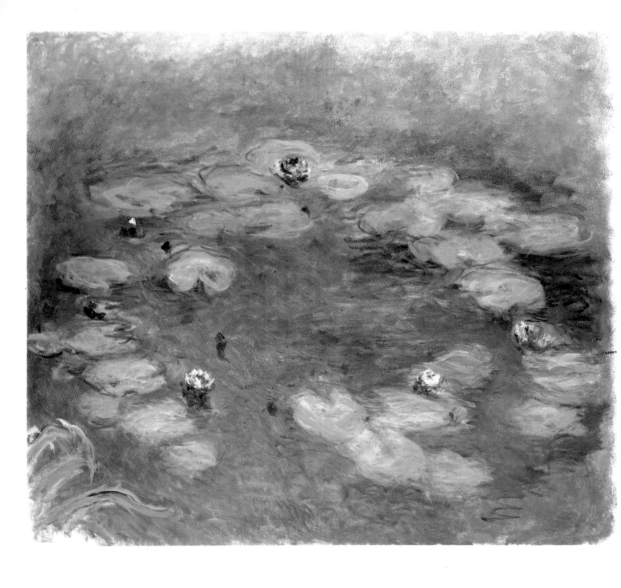

49　Monet　*Water Lilies*

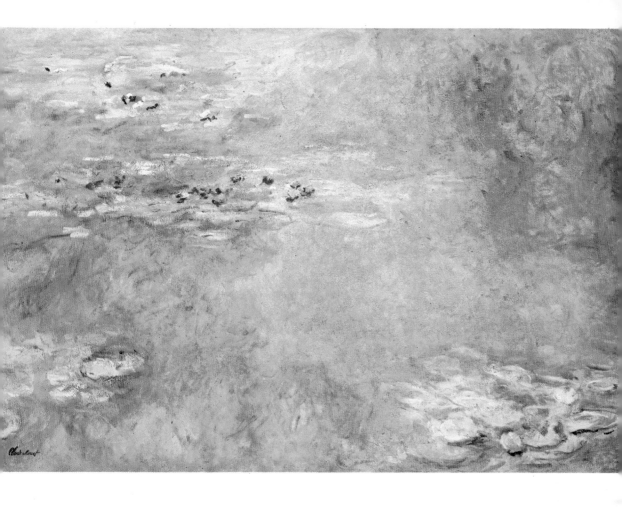

50 Monet *Water Lilies*

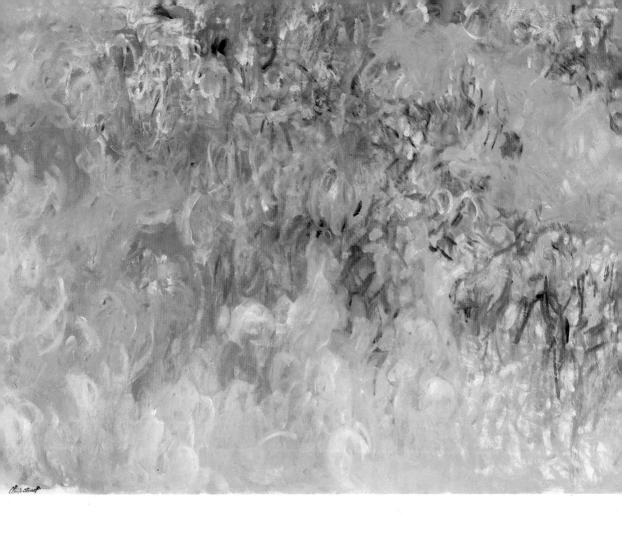

51 Monet *Glycines*

52 Monet *Iris Reflected in Yellow* 192

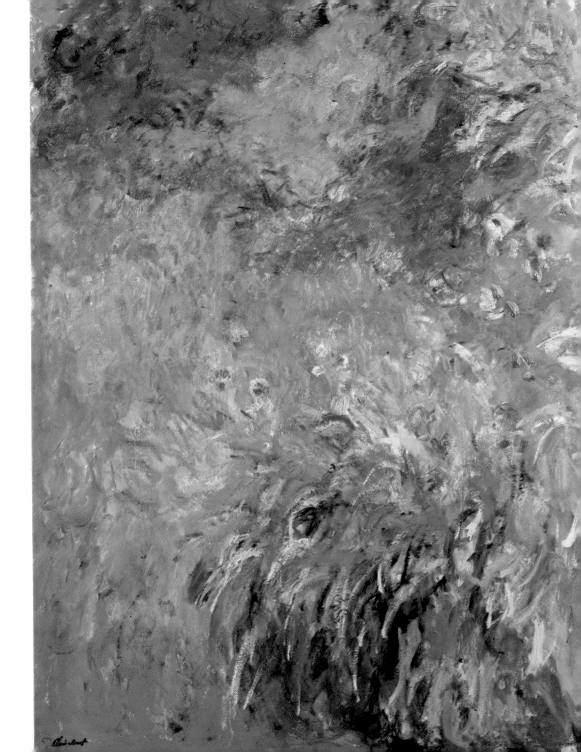

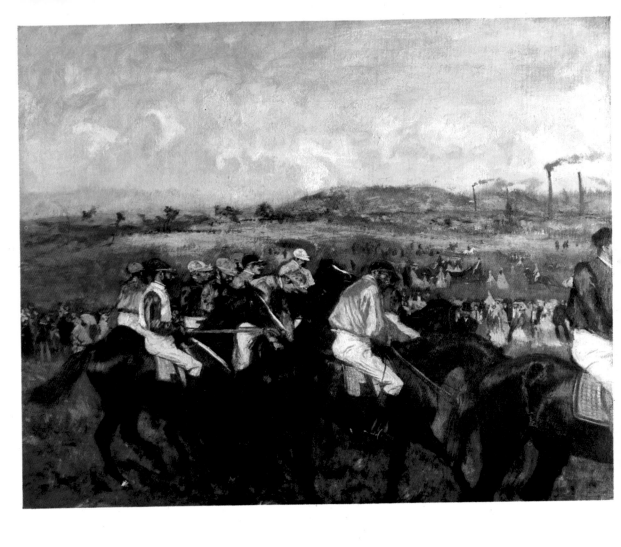

53 Degas *Amateurs' Race, before the Start* 1862 Louvre Paris

54 Degas *Portrait of Thérèse Degas, Duchess Morbilli* 1863 Louvre Paris

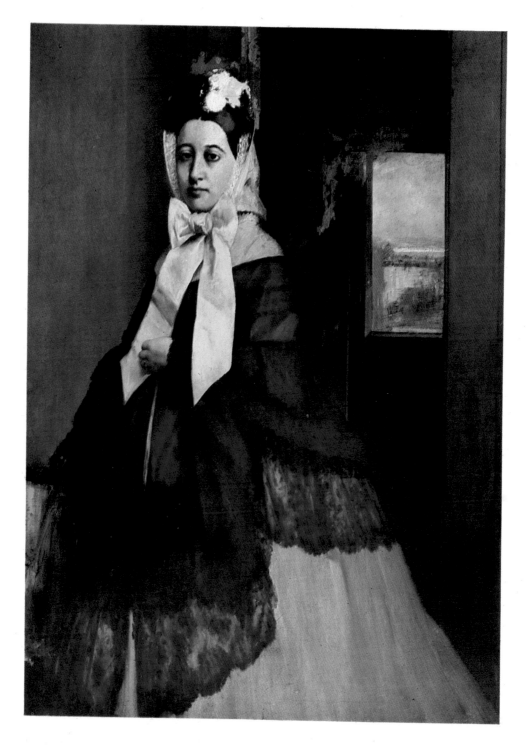

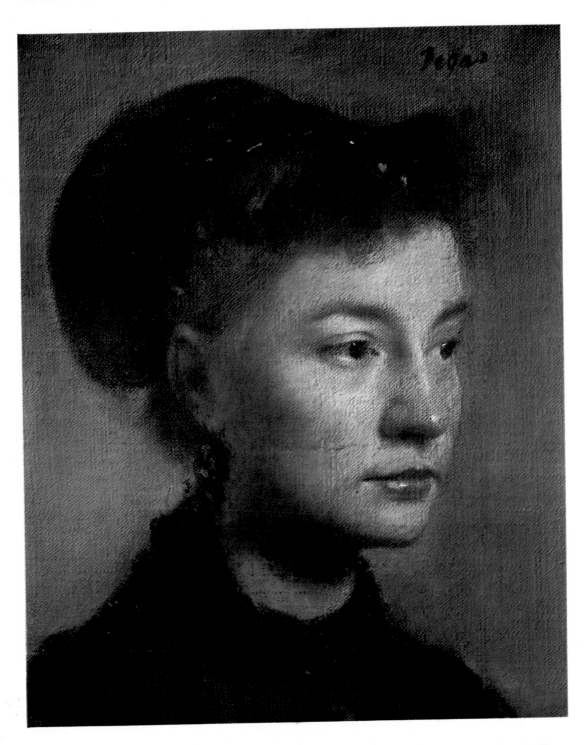

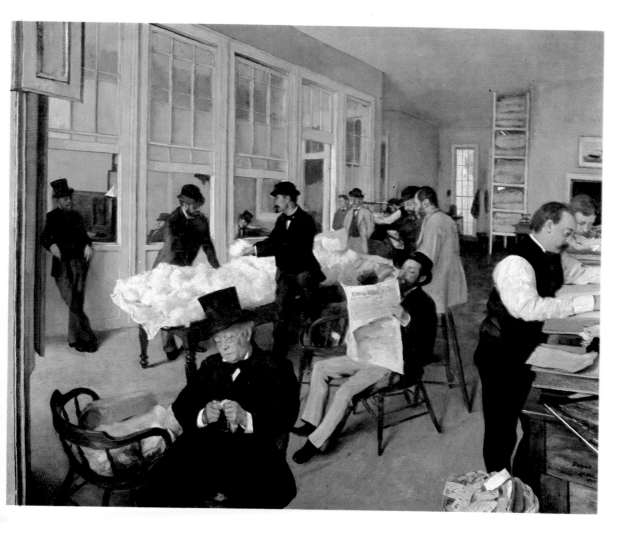

56 Degas *The Cotton Exchange in New Orleans* 1873 Musée Municipal Pau

55 Degas *Portrait of a Young Woman* 1867

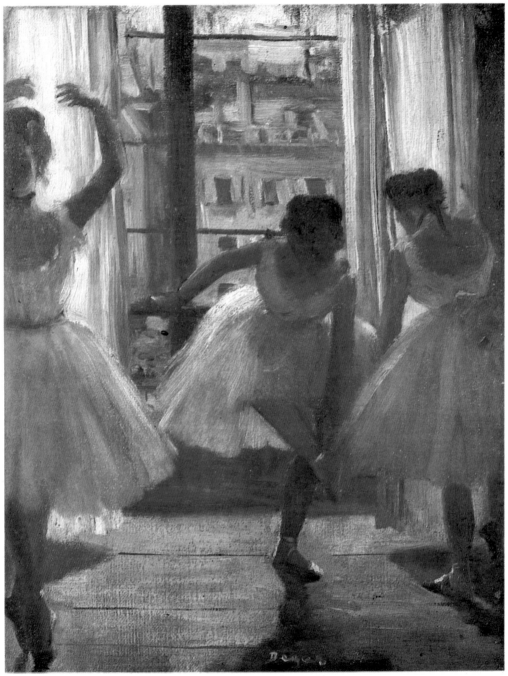

57 Degas *Three Dancers* 1873 Private Collection Paris

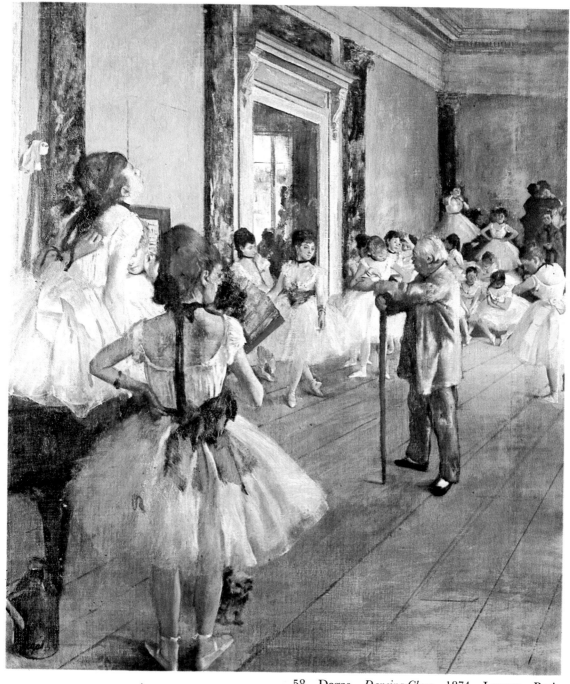

58 Degas *Dancing Class* 1874 Louvre Paris

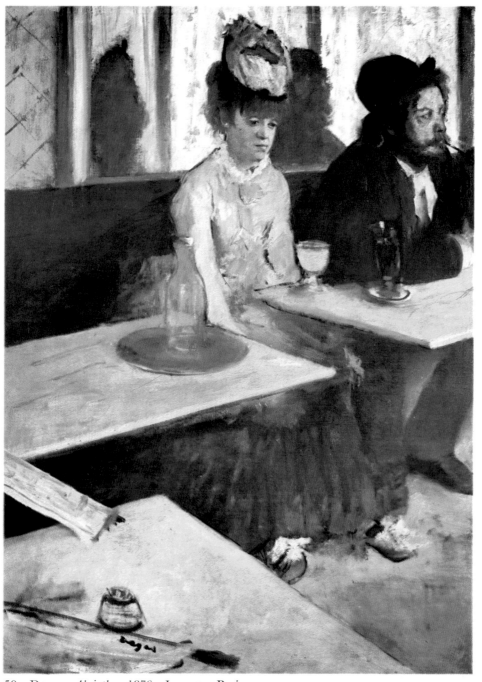

59 Degas *Absinthe* 1876 Louvre Paris

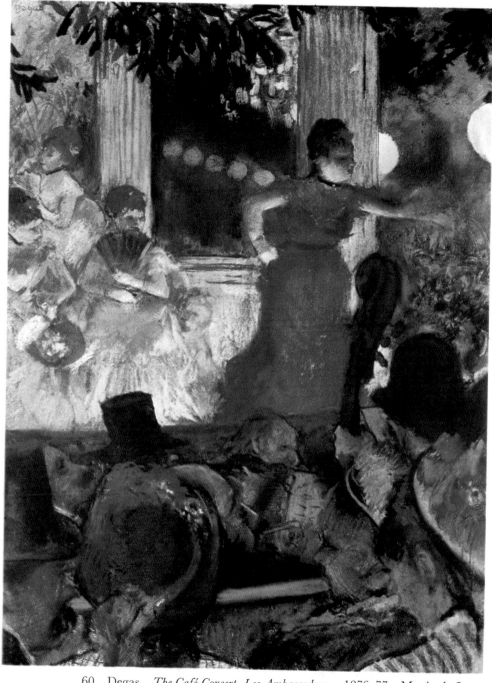

60 Degas *The Café-Concert, Les Ambassadeurs* 1876–77 Musée de Lyon

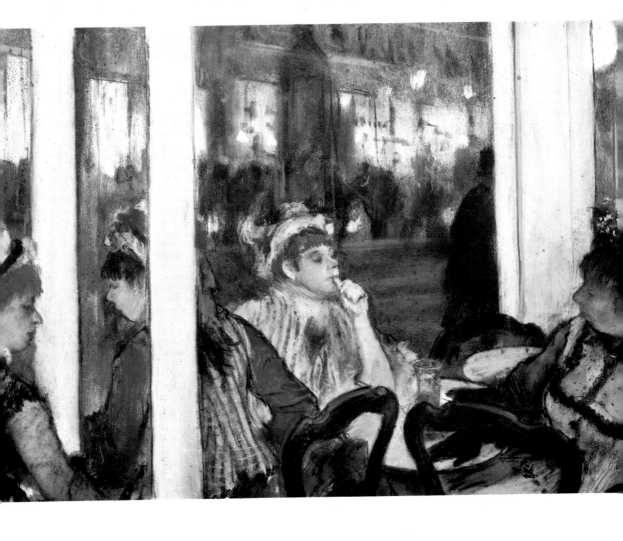

61 Degas *Women at a Café: Evening* 1877 Louvre Paris

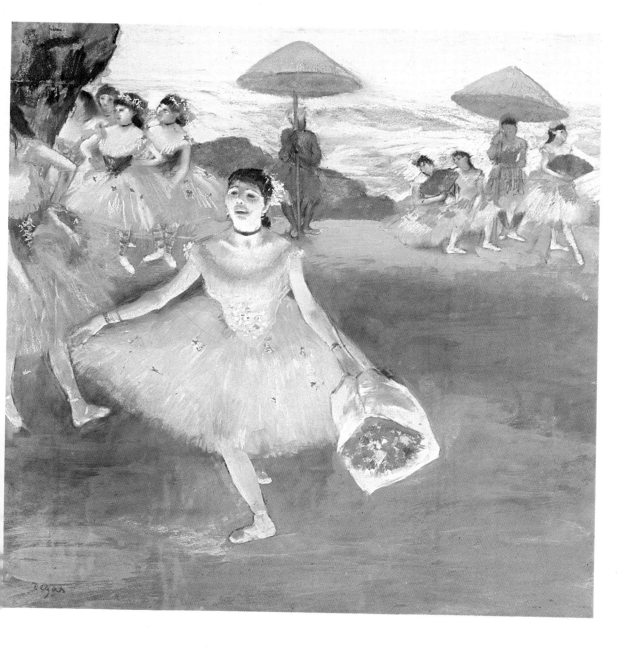

62 Degas *A Dancer with Bouquet, Taking a Bow* 1877 Louvre Paris

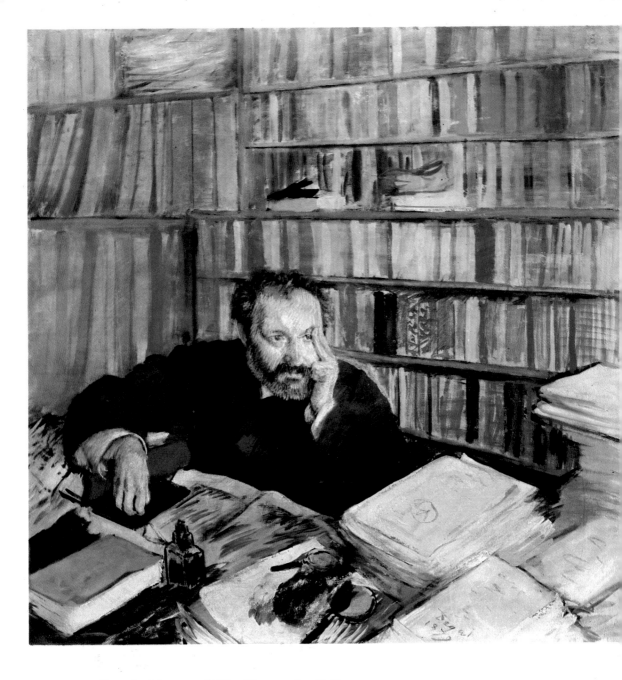

63/ Degas *Portrait of Duranty* 1879 Glasgow Art Gallery

64 Degas *Portrait of Diego Martelli* 1879 National Gallery of Scotland Edinburgh

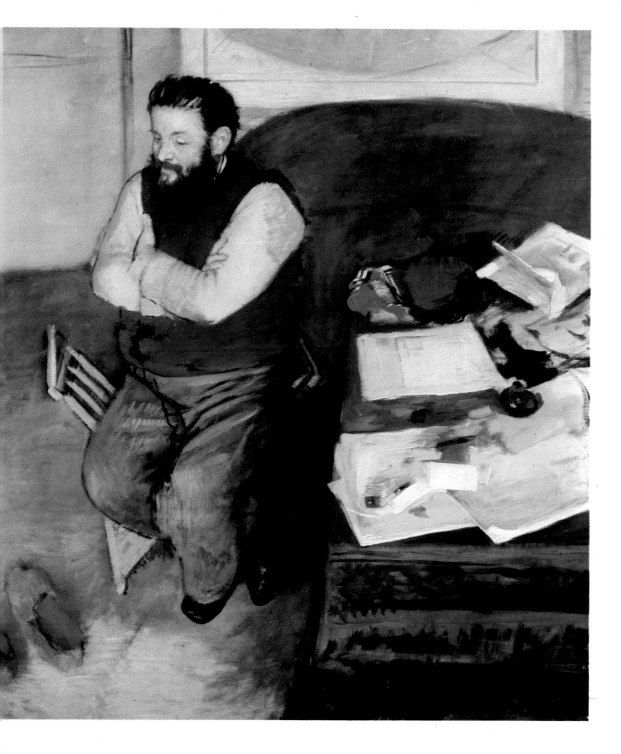

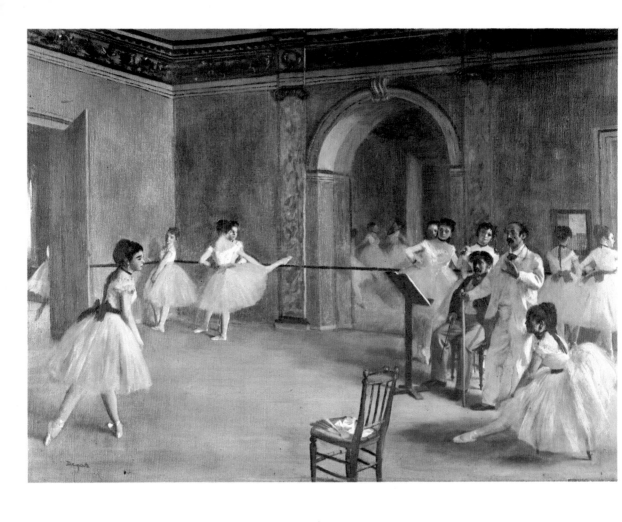

65 Degas *The Dance Foyer at the Opera, Rue le Peletier* 1872 Louvre Paris

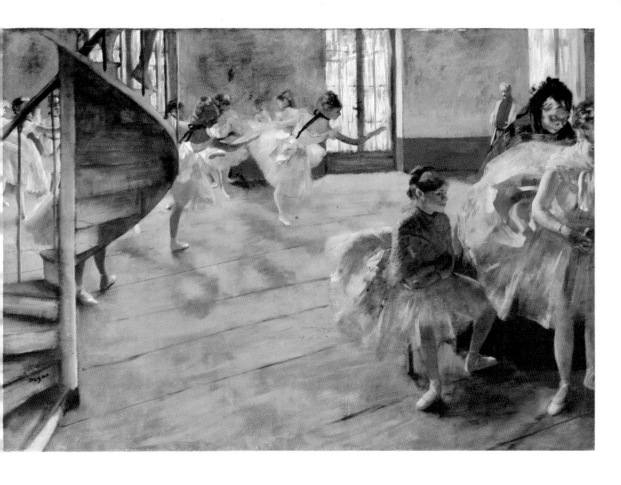

66 Degas *The Rehearsal* 1879 City Museum and Art Gallery Glasgow

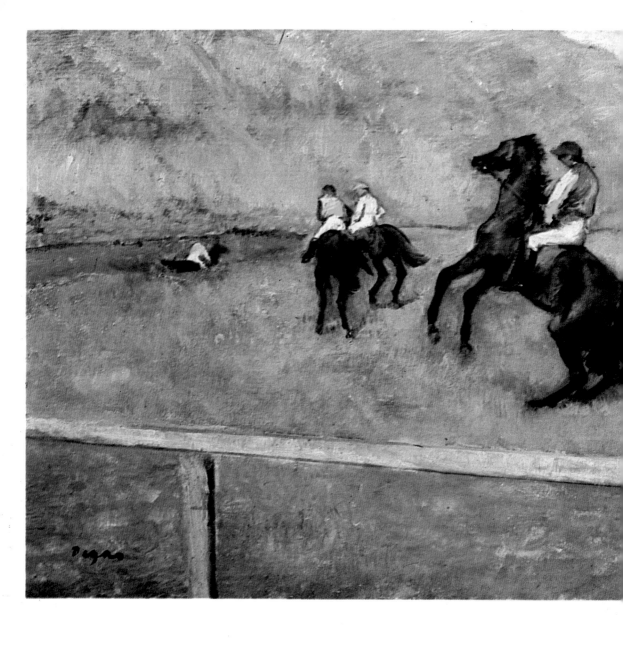

67　Degas　*Race Horses*　*Circa* 1878–80　Bührle Collection　Zürich

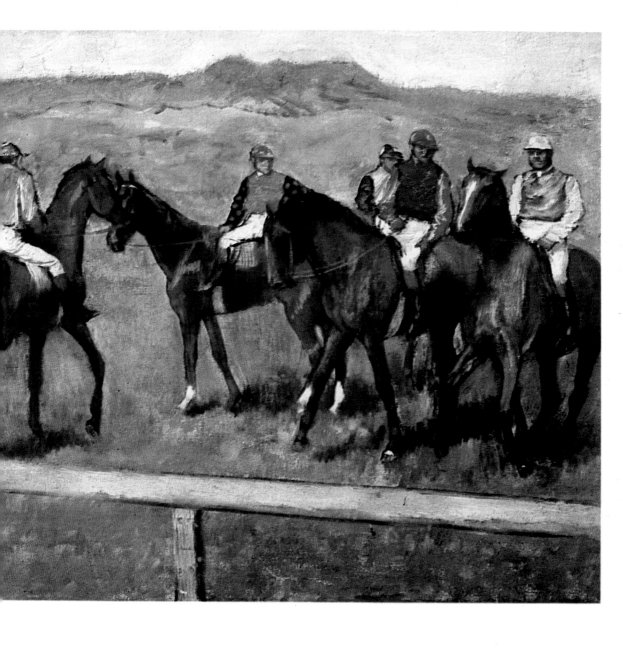

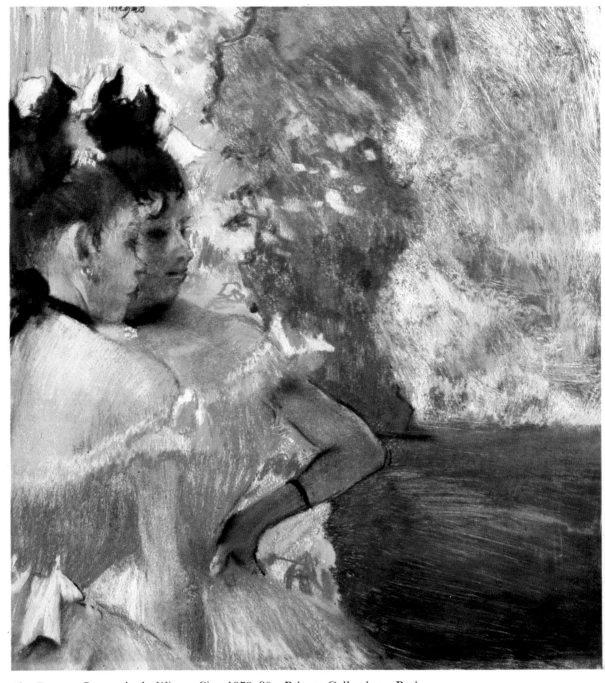

68 Degas *Dancers in the Wings* *Circa* 1878–80 Private Collection Paris

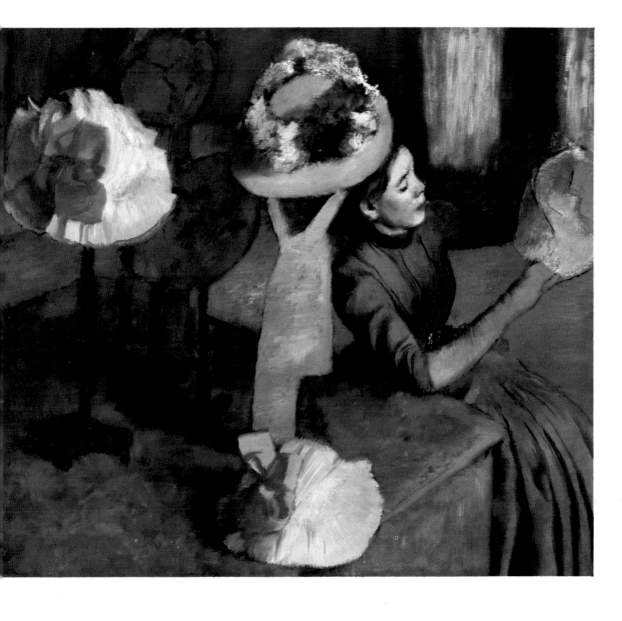

69 Degas *The Milliner* *Circa* 1882 Art Institute Chicago

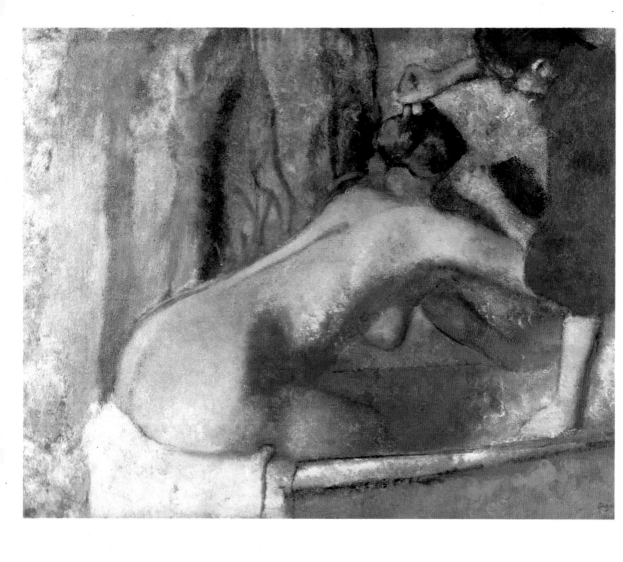

70 Degas *Woman in the Bath* Toronto Art Gallery

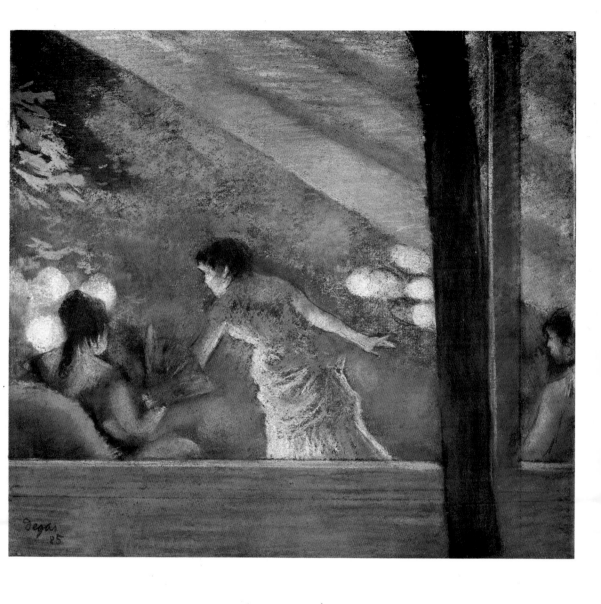

71 Degas *Café-Concert* 1885 Louvre Paris

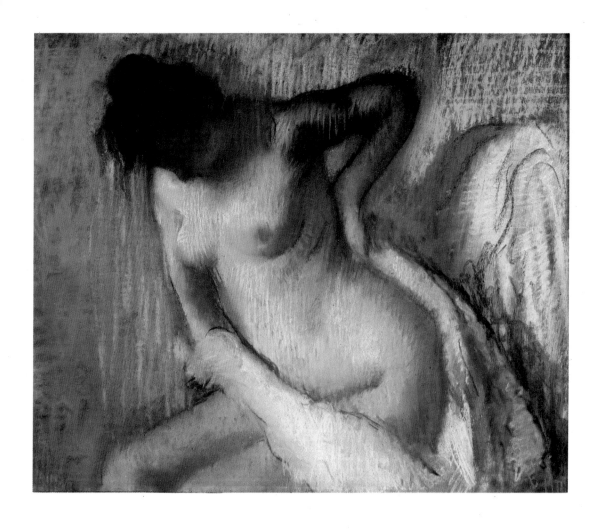

72 Degas *Woman Drying Herself*

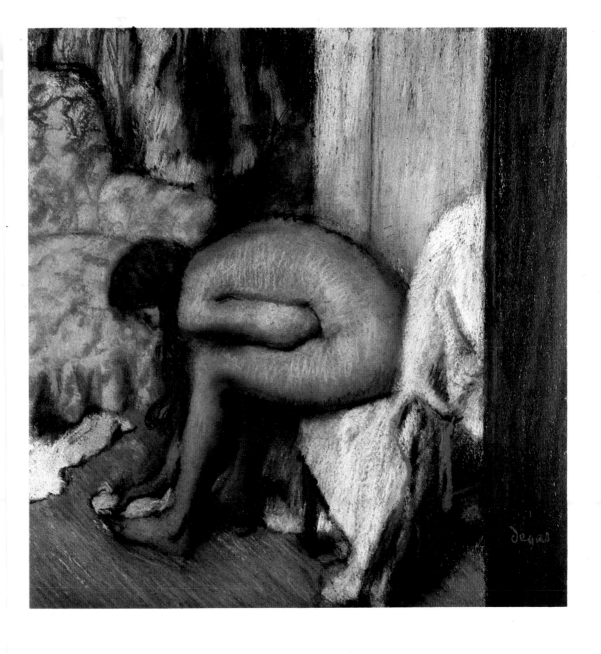

75 Degas *After the Bath, Woman Drying Her Feet* 1886 Louvre Paris

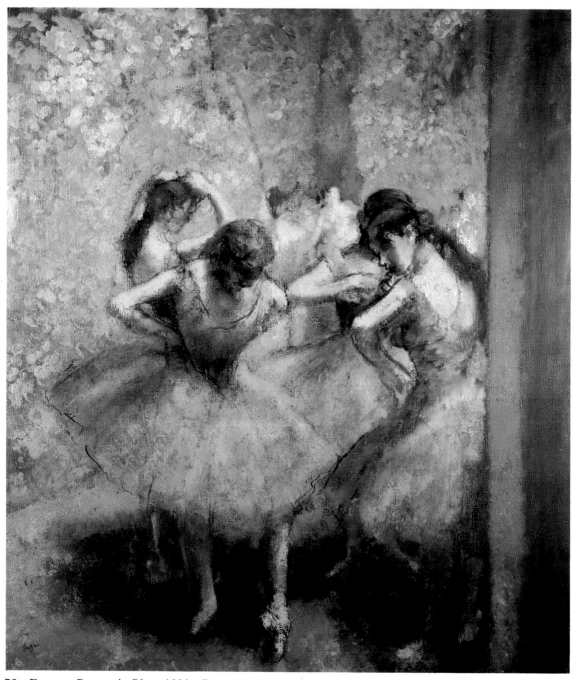

76 Degas *Dancers in Blue* 1890 Louvre Paris

Manet/Monet/Degas

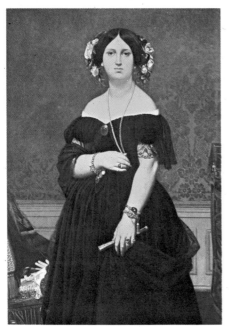

Ingres, *Madame Inez Moitessier* (1851)

Corot, *Recollection of Pierrefonds*

The Dawn of Visual Perception

Modern painting was born in France during the nine-
teenth century. French painting in the early decades was
dominated by the classical tradition, with subject and treat-
ment largely prescribed. Draftsmanship of great precision
and infinite detail was essential. Subject matter, apart
from portraiture, derived from classical text—historical,
literary, mythological, or religious—and was portrayed
with an idealized dignity. Paintings in the classical mode
told a clear story in universally recognizable terms and in
the best of contemporary taste. That taste was largely
determined by the French Academy and regulated by the
judges of the Salon, who selected from among the paintings
submitted those to be exhibited. Reputation as well as
livelihood required the blessing of those judges. And since
the painters of the Academy were traditionalists, as well as
the accepted teachers of the Ecole des Beaux-Arts—the
most sought-after training ground for aspiring artists—the
classical school appeared firmly established and in little
danger of displacement.

The first threat to classical domination had scarcely the
substance of an aesthetic upheaval, although the uproar
that echoed across the chamber of the Academy, through
the corridors of the Salon, and in the press suggested a

mighty battle. The romantics, who easily captured public fancy and eventually Academy acceptance, merely shifted emphasis within the classical sphere. Draftsmanship gave way, but only in mild degree, to color; dignity diminished slightly in favor of drama. The romantics, clinging to the same source of subjects and virtually to the same precision of treatment, sought to emphasize emotion and thereby to heighten the appeal of their paintings.

Jean-Auguste-Dominique Ingres was the leading master and spokesman for the classicists, Eugène Delacroix for the romantics. Both were brilliant technicians and intense antagonists. Each became a member of the Academy, although Delacroix had a lengthy wait; and both their schools were accepted within the convention of traditionalist painting. For the first half of the nineteenth century, the classic-romantic mode, leaning upon an exposition of academic subjects, remained a force in French painting—but not the only force.

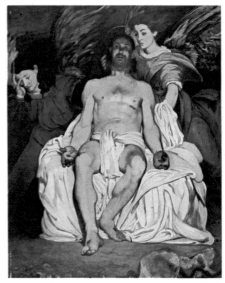

Manet, *Christ with Angels* (1864)

Before the mid-point of the century, still another movement in French painting became sharply, albeit controversially, evident. Camille Corot, Gustave Courbet, and Jean-François Millet were among those independent artists who defied both tradition and popular taste and led the transition into realism. They cast aside the prescriptions of historico-classical subject and precision technique and chose instead to paint the actual, observable, and commonplace world about them in a freer style. They painted that world faithfully and, by their choice of subject and treatment, could introduce a new sense of feeling as well as humane significance into contemporary art.

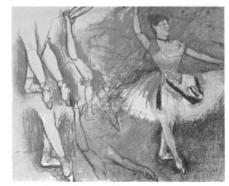

Degas, *A Dancer Holding a Tambourine*

Paris World's International Exhibition of 1867. This world's fair established the pattern of modern expositions by stressing culture rather than industry.

Boudin, *Brussels Canal* (1871). The encounter of Boudin and Monet in 1858 changed the course of impressionism.

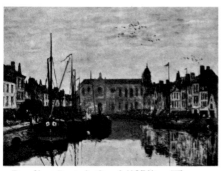

Jongkind, *Landscape with Windmill.* Johan Barthold Jongkind (1819–1891) was born in Holland. His style greatly influenced Monet and other impressionists.

The romantics can be seen as an extension of the classical tradition, a welcome variation within a stylish pattern. Not so the realists. These were rebels, cherishing independence and individualism as much in their lives as in their art. If modern art can be traced to a singular beginning, it would be with the realists. From that start, modernism evolved along many lines, took more and more divergent paths, until today it sweeps from the extreme of the ultrarepresentational to the subjectivity of abstractionism. If realism was a rebellion, then impressionism was a full-scale aesthetic revolution. Édouard Manet, Edgar Degas, and Claude Monet played important roles in it.

These three extraordinary painters were born within ten years of one another—Manet in 1832, Degas in 1834, and Monet in 1840. Theoreticians have suggested that art may mirror history. If that is, even in part, a valid concept, these three entered a world charged with upheaval and punctuated by violent change. It was less than half a century before their births that the Bastille was stormed and the First Republic emerged from the Reign of Terror. Less than a quarter of a century separated them from Napoleon and the First Empire. They barely missed the Revolution of 1830 that toppled autocratic Charles X and led to their Citizen King, Louis Philippe. They were to live through the Revolution of 1848, the brief Second Republic, the Second·Empire, and, after the Franco-Prussian War in 1870–71, the Third Republic.

Thus, in the early 1860s, when the three artists started producing their work, Napoleon III was on the throne of

France and the Industrial Revolution was creating a new socio-economic nation—the railroad was expanding, communication systems were developing, and commerce was booming. Paris was at the height of prosperity. The bourgeoisie celebrated the dawn of a bright new era. Coffee shops flourished and the cafés were crowded with young artists and writers. France's affluence was symbolized by the World's International Exhibition of 1855 and the one to follow in 1867. Tourists from all over the world flocked to Paris, the thriving center of fashion and art.

Beneath this façade of prosperity lay a restless and, in some elements, miserable people. The new industrialists became France's leaders, their rise stemming from financial power and influence. Workers, as in all incipient industrial societies, saw themselves as forgotten, dehumanized, outcast. The middle class, having attained a new level of comfort and acquisition, and recognizing its strength as a political entity, questioned the concept and value of a privileged aristocracy. The inevitable pressures of an urbanized industrial society began to build.

To equate Manet and the impressionists directly with social upheaval might cloud the history of art. Still, until their emergence, it is impossible to find another time and place in the record of civilization when such a radical departure in art could have arisen, developed, and endured. Today, when innovation is not merely welcomed but nurtured and encouraged, it may be difficult to appreciate the constraints upon artists a century ago. In speculative retrospect, it seems that life and fate conspired to set these particular men in this particular moment of history.

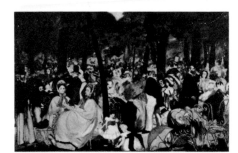

Manet, *Concert at the Tuileries* (1860). At first glance, the style appears rough, but the painting conveys the feeling of a crowd waiting for a concert to begin.

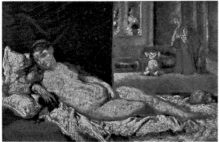

Manet, *The Urbino Venus* (1856). A copy of Titian's work. During 1856 Manet traveled to Holland, Germany, Austria, and Italy, viewing many great paintings.

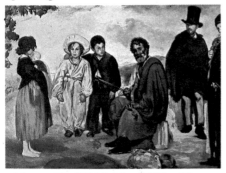

Manet, *The Old Musician* (1862). Manet rented a studio at Batignalles in 1862. The previous year he met the poet Baudelaire and the writer Duranty. They both greatly impressed him.

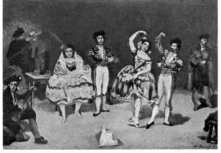

Manet, *The Spanish Ballet* (1862). Here can clearly be seen a Spanish influence on Manet's paintings. He was called a Spanish artist in Paris.

Édouard Manet was an unwilling revolutionary, but his obsessive honesty and his dedication to his personal values in art set him glaringly apart from the tradition-bound, authoritarian jury of the Salon. Manet came from a well-to-do family, and was pressed to follow his father in the profession of law. He begged off, agreed to apprentice for a naval career, and, fortunately for the world of art, failed his examinations. He was at last permitted to study painting in Paris. Temperamentally unequipped to play the customary politics of the Salon, incapable of performing the ritual of strict conformity, Manet was not the typical student. Supported by his family, he was not the typical struggling young artist. But, being talented and human, he expected opportunity and recognition.

His first works were conventional and after one season of rejection, he encountered success at the Salon in 1862. Encouraged by that, he submitted three paintings for the 1863 showing. They were rejected by the increasingly reactionary Salon jury—as were more than half of all the submissions that year. Napoleon III, in an unexpectedly liberal gesture—possibly provoked by the shrill protests of both artists and public—allowed a concurrent exhibition for all the rejected paintings, and Manet's three paintings were hung at the Salon des Refusés. One of them caused a scandalized outcry. Since that event it has been acknowledged as one of the finest works of a great master. Originally the painting was called *Le Bain* (*The Bath*), but constant later reference to it as *Le Déjeuner sur l'Herbe* (*Luncheon on the Grass*) gave it the title by which it is known today.

This striking and beautiful painting has virtually all the ingredients of entirely acceptable and highly successful paintings of that time—a seated nude and two reclining male companions against an idyllic landscape. Had Manet garbed the men in costumes of mythology so that the unclothed woman might be considered a woodland nymph, the painting might easily have been applauded. But he clad his men in the clothing of the 1860s, and for no other apparent reason he was charged with vulgarity, indecency, immorality. The fact that a Renaissance painting by Giorgione might have served as the thematic inspiration, and that an engraving adapted from a painting by Raphael undoubtedly served as the model for composition, did not diminish the vehemence of criticism. Manet, it might seem from a more just perspective, had flaunted a convention, had shattered a minor rule. But seen from the remove and hindsight of a century later, it is clear that, through sheer honesty and conviction—that admirable combination of traits once acclaimed as artistic integrity—he had flaunted pretentiousness, had shattered a massive barrier. Nothing less than the concept of art for its own sake was being forged. And for the artist—Manet's contemporaries as well as his successors—life would never be the same again.

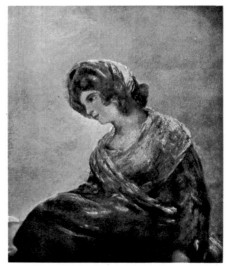

Goya, *Milkmaid at Bordeaux* (1827). The bright color tones are a precursor of impressionistic techniques.

Two years later, in 1865, Manet's *Olympia* reinforced his stance. This lush reclining nude in the classical pose might have been endowed with a faraway look and surrounded by cupids—a conventional Venus. Manet painted her as a stocky Parisian, an ordinary woman. Once again debate soared, this time the apologists citing Titian's *Venus of Urbino* and, more appropriately, Goya's *Naked Maja*. Yet *Olympia*, as time would demonstrate, needed no justification

Manet, *The Execution of Emperor Maximilian*

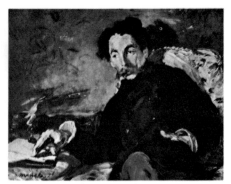

Manet, *Portrait of Stéphane Mallarme* (1876). Since 1874, Mallarmé had been a defender of Manet. Mallarmé translated Poe's "The Raven" and Manet painted an illustration for it.

other than its existence and the sense of communion it created in its beholder.

In 1867, Manet commenced work on another painting that eventually drew fierce critical blows—*The Execution of the Emperor Maximilian*. This crisp, unsentimental portrayal of the ill-fated Austrian aristocrat, whose disastrous reign as monarch of Mexico ended with Napoleon III's abrupt and cowardly withdrawal of military support, could not help offending two authorities: Napoleon III because it brought into focus his shame, and the traditionalists because it failed to veil the blunt grimness of the event with heroic posturing or thematic idealization. It was barred from public exhibition in France.

Over the next fifteen years Manet's work gained in critical approval, market value, and public acceptance. He continued to paint exactly as he wished, never compromising in subject matter, often experimenting in technique. When he encountered a strikingly new or appealing approach, such as Japanese prints, he applied elements of them to his own interpretations.

Manet longed for success in the Salon and, in increasing measure, achieved it. Yet, until 1881—just two years before his death at the age of fifty-one—he had not received full official recognition. In that year he was awarded a medal by the Salon and the Legion of Honor by the government.

Manet never considered himself one of the impressionists, although he welcomed the company, the work, and the concepts of many of them. He never chose to show his

Manet, *Lunch in the Studio* (1868–69). A color scheme of white, gray, and black positions the three figures carefully.

paintings in any of the seven impressionist exhibitions that took place during his lifetime, although he was frequently invited to do so. Had he accepted, there is no doubt that he would have been acclaimed as the first and foremost of that fascinating and eventually illustrious band of aesthetic brethren.

Manet declined to label himself or his work as belonging to any group, to any movement. It is well that he did. For, across a century, Manet emerges as a giant—the creator of supremely individual, brilliant works of art that will endure in their own right. He led the way to complete independence in painting. Others were to employ that independence in a variety of fascinating ways. Something of Manet lives in the very fact that modern artists are free.

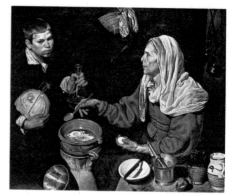

Velàzquez, *An Old Lady Cooking Eggs* (1617–22). In Caravaggio-style illumination, the light coming from the left, the white veil of the old woman stands out clearly against the dark background.

Claude Monet was born in Paris eight years after Manet. Monet's father was a grocer of modest means and little education. He moved his family to Le Havre when young Monet was five and there, in the thriving seaport, Monet grew into an unsophisticated but vital and determined youth. Without training of any kind in art, the teen-age boy could not resist drawing his father's customers and the people of the community. His sketches were admired, sought after, and displayed. By sheer good fortune the painter Eugène Boudin saw them and strongly recommended that the young man pursue art as a career.

In 1859, the nineteen-year-old Monet arrived in Paris to commence study at the Académie Suisse. Throughout the 1860s, his life was turbulent and he was constantly plagued

Monet, *Camille with a Puppy* (1866). The realistic touch suggests Courbet's style in this portrait of Madame Monet.

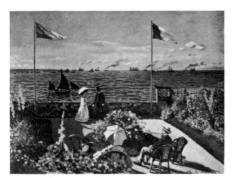

Monet, *Terrace near Le Havre* (1866).
This painting reveals his lifetime long-
ing for the light and the wind.

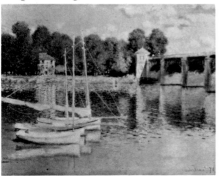

Monet, *The Bridge at Argenteuil* (1874).
After travels abroad Monet settled in
Argenteuil for about four years.

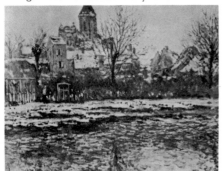

Monet, *Vétheuil: Effect of the Snow*
(1878). Monet stayed in Vétheuil on
the Seine, west of Argenteuil, for three
years.

by debt. He fulfilled his military service with the army in Algiers in 1861, returned to Le Havre for several months in 1862, then went to Paris to study at Gleyre's studio. He frequented the haunts of the young struggling artists, in particular the Café Guerbois where he met, reveled, and argued with the bold new painters who had yet to achieve recognition and success. It may be that one of the most extraordinary movements in art had its unrecognized beginnings in these vociferous gatherings.

Monet had a modest success in 1865, when two of his paintings, accepted by the Salon, won praise. The following year his portrait of his mistress, called *Camille*, gained greater applause. In 1867, *Women in the Garden* was rejected by the Salon, and so began the series of rejections that in 1872 caused Monet to determine never again to exhibit a work at the Salon. He maintained that stance until 1880, when he submitted two paintings; one was accepted, one was rejected. After that Monet in fact never submitted another work to the Salon. But by 1880 he had little need of that august showplace, for his paintings had finally gained popularity among purchasers who could recognize his brilliant originality and technique and offered substantial sums for his work.

Monet's career, in its essentials, developed apart from the Salon. Surely he was influenced by those painters committed to aesthetic independence; in the mid-1860s he grew to know Manet, Renoir, Courbet, Bazille, Sisley, Degas, Pissarro, and Cézanne. The adventurous eagles of impressionism were gathering, although they were not clearly aware of their identity or purpose.

It is probable that Monet's love of nature, stemming from his youth near the sea and countryside, was of equal importance to the work he would achieve. He, along with other young rebels, departed the studios and sought subject matter as it lay revealed in abundance and infinite variety in the light and living world.

By 1873 Monet had reached the confident strength of his capacities and conviction. He had become spokesman for the group of young innovative painters and leader in the cause of an independent exhibition of their work. In 1874 that showing took place to the raucous sneers of the critics; one such, noting a painting of Monet's entitled *Impression, Sunrise*, labeled the collective painters, some thirty in all, "impressionists," and minted the description "impressionistic" for their efforts. His coinage, basely intended, has since become purest gold.

The key to impressionism, if one statement can embrace the totality of so many differing and effective attitudes and styles, is the artist's privilege, indeed his obligation, to depict the things of this world as he sees them, not as he knows them to be. Thus light and movement play telling roles in creating auras of color, in blurring defined shapes. And once having gone beyond the precision of reality into the subjectivity of personal, momentary observation, it was natural, even inevitable, that the artist would add his sense of feeling to his sense of vision.

Between 1874 and 1886 a total of eight impressionist exhibitions took place, but well before the last of them many of the originators were taking separate roads to new

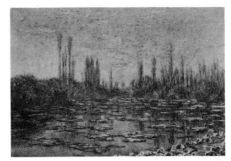

Monet, *Floating Ice* (1880). In 1879 Camille died in Vétheuil, leaving behind two sons.

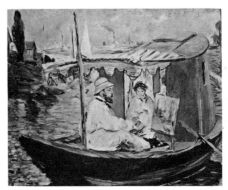

Monet, *Monet Painting the Floating Studio* (1874). Monet was always a careful observer of the effect of light.

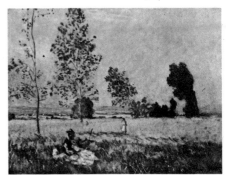

Monet, *Spring* (1874). Monet painted not only the effect of light but also delicate and violent atmospheric changes.

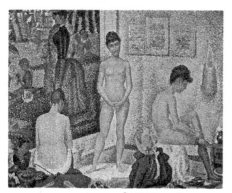

Seurat, *Posing Women* (1888). Georges Seurat (1859–1891) was born in Paris. He studied the color theory of Cheureul, and together with Signac developed pointillism.

Monet, *Poplars* (1891). A row of poplars along the Epte, a tributary of the Seine, charmed the muse in Monet.

and more advanced experimentation and achievement. Impressionism as a cohesive movement was ended, but its liberating force and effect in painting glow vibrantly into our own time.

Monet continually developed brush techniques. Dimension, shape, and quantity were transitions of color tones; color was applied in strokes of various lengths and rhythms; contour was indicated by broken strokes. Yet technique was secondary to desired effect—and for Monet the effect sought was the capturing of the elusive appearance, the transitory play, of motion and of light. He set out to arrest such transient phenomena as smoke dispersing in the air, leaves dancing in the wind, and passing clouds. His more intense studies of light are dramatically recorded in such paintings as *Old Saint-Lazare Station, Snow Scene, Haystacks,* and *Poplars.* Perhaps the most breathtaking is the series on *Rouen Cathedral,* where time and light and mood are merged intrinsically with place.

Monet took up residence at Giverny in 1883 and worked there on his most ambitious series, *Water Lilies.* His later works, among them *Wisteria* and *Iris Reflected in Yellow,* show the blending of his spirit into nature as a mellowed, subdued abstraction. His long life, filled with work to the last, ended in 1926. His advocacy of artistic freedom may be part of the record of history, but his work, embracing hundreds of treasured paintings, is a living monument to liberty.

Edgar Degas was born two years after Manet, six before Monet. His father was a successful banker (the family

name was actually de Gas), his mother a highborn French-woman from New Orleans. As a youth and student Degas never knew financial hardship and was able to paint without concern for earning a livelihood.

The young Degas may be viewed as a conservative. His instruction was at the École des Beaux-Arts, and his early work falls decidedly into the classical tradition. His person-ality was that of the aristocrat; he disdained common popularity, indulged in sarcastic comments toward the ambitious, shunned the libertarians of the art world and the Paris social scene.

He was sometimes drawn into the company of the young rebels, but more as an observer than a participant. His early work, mainly portraiture, was well fashioned in the formal mode and frequently accepted by the Salon.

Historians differ in emphasis—and, indeed, in knowl-edge—on the causes of the change in Degas's work. Dis-satisfaction with his unchallenging, conventional output; fascination with the possibilities in the new and experi-mental painting; shock at the defeat of royalist France in the Franco-Prussian War; or possibly a miserable romantic experience. One, more, or all of these may have been factors in establishing the forty-year-old man as a lonely bachelor with a dominant professional interest in scenes of ballet, of horse racing, and of Parisian café life. When he was over fifty, he shifted his subject to the female nude, often in attitudes of bathing, invariably indoors and il-luminated by artifical light. Although unclothed women often appear in his work, there is no suggestion of the erotic.

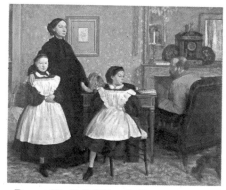

Degas, *The Bellelli Family* (*Circa* 1860–62). Degas traveled to Italy in 1856 for the first time and stayed with Baron Bellelli and his family in Florence. After re-turning home he produced this master-piece.

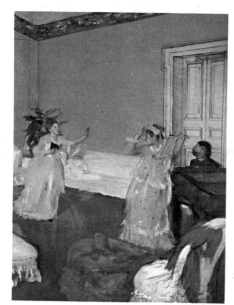

Degas, *The Rehearsal* (1873). Degas was interested in the gay, modern life of Paris and painted the attractive and lively movements of an opera rehearsal.

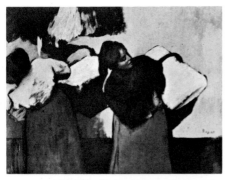

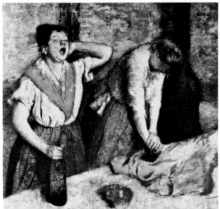

(top) Degas, *Two Laundresses* (1876–78). (bottom) Degas, *Laundresses* (*Circa* 1884). Degas's series of laundresses deserves attention as much as his other series on dancers, race horses and the café-concert.

Intriguing as the psychological factors motivating an artist's painting may be, it is his work that endures. Degas, when he finally broke with tradition, produced a brilliant assortment of paintings that achieved almost immediate applause. The popularity of those paintings endures today. He exhibited with the impressionists, and his technique and approach make him a true contributor to that movement.

Degas was fascinated by motion in a degree similar to Monet's preoccupation with light. But he added one remarkable element that can be considered a hallmark to much of his work—creative perspective. He not only viewed his subjects from several angles—and at times from an incline or aerial perspective—but also combined them on one canvas. The result is not merely a capturing of movement, but an almost cinematic portrayal of motion as the eye travels from one form to the next.

Degas was not only a painter, but a student and collector of art. He was caught by the figure panoramas and composition of Japanese art, which was prevalent and admired in Paris at the time, and he may have been more influenced by it than any other impressionist. Certainly his strength of multi-figure composition remains unsurpassed.

His brushwork, although unconventional, is deliberate—impeccable as much as inspired. In fact, Degas labored over his paintings in a manner uncommon to most of the impressionists, who delighted in the rapid execution of the passing moment. Yet he caught the transient scene, the singular moment's vision, as forcefully and vividly as any.

Degas's sight began to fail him when he was in his sixties and his work naturally diminished. His later years found him a figure of curiosity, a strange, unkempt old man, shuffling about Paris, seemingly lost and, as an individual, almost a legend. He was eighty-three when he died in 1917. Degas, who was so conventional in his beginnings, left a legacy of modernism that finds immediate response and will remain a model for painters still to come.

Manet, Monet, and Degas were present at the dawn of a new sense of vision that has made the horizon of art unlimited.

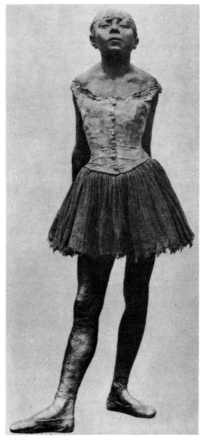

Degas, *Fourteen-Year-Old Dancer* (1874–81). His eyesight failing, Degas turned more and more to sculpture. Though he referred to his works as "fingerings of a blind man," they loom large in the history of modern sculpture.

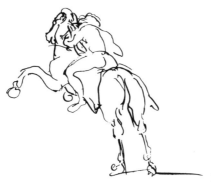

Degas, *Study of a Race Horse*

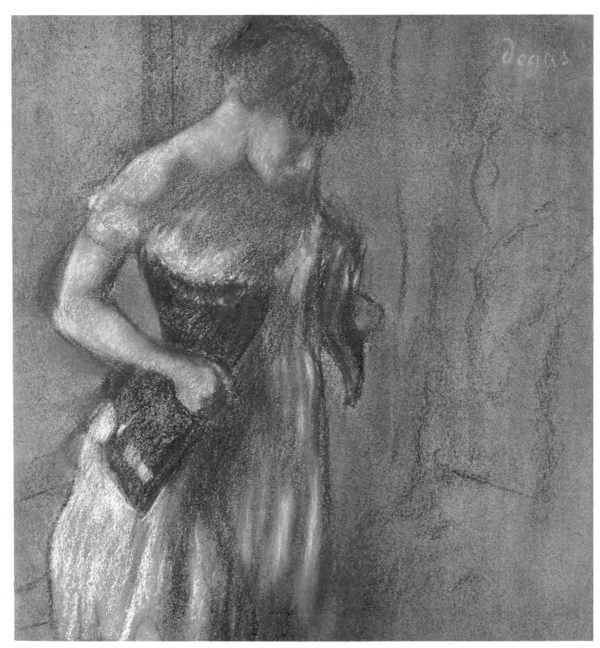

Degas, *Woman Putting on Corset*

NOTES ON COLOR PLATES

Édouard Manet (1832–1883)

1. *Portrait of Monsieur and Madame Auguste Manet*

 1860 Oil on canvas 109.9 × 89.8 cm Private Collection, Paris

 This portrait of the artist's parents was exhibited at the 1861 Salon and gained public favor. Manet's father, a prominent official in the Ministry of Justice, was fourteen years older than his wife. Although the artist was strongly influenced by the Spanish school at this time, the portrait does not reveal aristocratic dignity, nor does it attempt to flatter or sublimate its subject. It is said that an old family friend gave his impression of the painting, saying, "A lady like Madame Manet is to be pitied, to have been drawn like that. Indeed, examine closely the figures of both parents; they resemble a watchman and his wife." The work is a strong contrast between dark and light, an effect that is characteristic of much of Manet's painting.

Manet, *Self-Portrait with Palette* (1879)

2. *Le Déjeuner sur l'Herbe (Luncheon on the Grass)*

 1863 Oil on canvas 214 × 300 cm Louvre, Paris

 This painting was formerly called *Two Couples at Play*, and *The Bath*. It was shown at the 1863 Salon des Refusés, an exhibition of rejected works, and provoked shock and criticism. In the center of the painting three persons are grouped in the shade of trees. The man on the right is the artist's brother, Eugène Manet, and the man on the left is his future brother-in-law, a Dutch sculptor named Ferdinand Leenhoff. The nude is his favorite model, Victorine Meurend. In the sunlight in the background a woman is bathing her feet in the stream. The grouping of subjects is not intended to stress a resemblance to real life but shows, rather, a casual gathering in the light

97

(center) Giorgione, *Fête Champêtre* (1510)
(bottom) Marcantonio, *The Judgment of Paris*

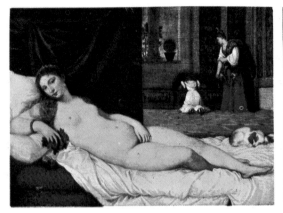
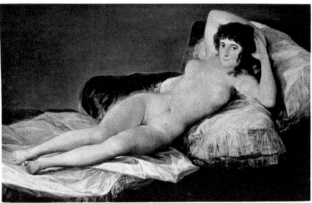

(left) Titian, *Venus of Urbino* (1538)
(right) Goya, *The Naked Maja* (1798–99)

and air along the banks of the Seine. The theme bears some relation to an idea of Giorgione's; the central group was adapted from Raphael's *The Judgment of Paris*, as copied in an engraving by Marcantonio.

3. *Olympia*

> 1863 Oil on canvas 130.5 × 190 cm Louvre, Paris

Wearied of the 1863 scandal provoked by *Le Déjeuner sur l'Herbe*, Manet did not consider exhibiting this painting. Two years later, after a strongly persuasive call to reason by Baudelaire, he agreed to put it on display. Probably no painting in the history of art has ever caused more violent commotion. The composition was inspired by Titian's *Urbino Venus* and Goya's *Naked Maja*. However, Manet was not thinking of portraying a sensuous, desirable female. He was merely attempting to outline a nude figure with the aid of color and contrast. *Olympia* was named after a poetic phrase of his sculptor/poet friend, Zacharie Astruc.

4. *The Fifer*

> 1866 Oil on canvas 161 × 97 cm Louvre, Paris

The influence of Spanish painting on Manet can be seen in this picture. It is thought that the boy was a member of the Emperor's court.

Velàzquez, *Lady with a Fan* (1644–48). This painting of a Spanish woman in plain clothing is a good example of Velàzquez's serene approach to art.

5. The Execution of Emperor Maximilian

1867 Oil on canvas 201 × 304.3 cm National Museum of Art, Mannheim

Hopes for the conquest of Mexico by Napoleon III were dashed when Hapsburg Emperor Maximilian, a leading figure of the French expedition, was captured and executed in Mexico in June of 1867. It is almost unnecessary to point out the obvious influence of Goya's *May 3, 1808, in Madrid* on this painting. The style of depicting observers at the execution is extreme, yet it is typical of Manet. While Goya's portrayal of his subject is intensely dramatic, Manet's firing squad and victims register a seeming indifference. The artist, though dealing with a vivid theme, tries to be unemotional.

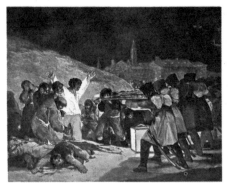

Goya, *The Shooting of May 3, 1814.* France invaded Spain on May 2, 1808. That was the start of a six-year struggle for independence from Napoleon's tyranny.

6. Portrait of Émile Zola

1868 Oil on canvas 190 × 110 cm Louvre, Paris

In February 1867 Zola wrote a critique of Manet's work for the magazine *XIXe Siècle*. In the following year Manet painted his portrait. For background, Manet used *Olympia*, a Japanese woodblock, and a study of flora and fauna.

7. The Balcony

Circa 1868–69 Oil on canvas 170 × 124.5 cm Louvre, Paris

Inspiration for this picture seems to have come from a balcony in Boulogne-sur-Mer. The composition is reminiscent of Goya's *Majas on a Balcony*. The seated woman in the foreground holding a fan is the artist Berthe Morisot; standing nearby is the musician Fanny Claus; and the man with a cigar is landscape painter Jean Baptiste Antoine Guillemet. A handrail and door are painted in Manet's oft-used color, sulphur green, and other hues of green and blue against the smooth satin-white set off the picture admirably.

8. Port of Boulogne by Moonlight

1869 Oil on canvas 82.0 × 101.1 cm Louvre, Paris

Manet visited Boulogne-sur-Mer often with his family. This view is from the window of the Folkestone Hotel.

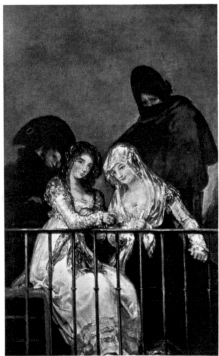

Goya, *Majas on a Balcony* (*Circa* 1796)

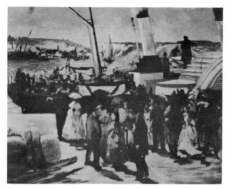

Manet, *The Departure of the Folkestone Boat* (1869)

9. *The Departure of the Folkestone Boat*

1869 Oil on canvas 62.9 × 101 cm Oscar Reinhardt Collection, Winterthur, Switzerland

To Manet, the sea was power . . . the ocean permeating earth and man. Everywhere the rhythm of glittering, colored points of light depicts life forces, a technique that presages a later style of modern art.

10. *On the Balcony of Columns at Oloron*

1871 Oil on canvas 42.5 × 62 cm Bührle Collection, Zürich

Three red columns accentuate the distant clouds and the white balcony. Nothing in the composition is bound by the conventional laws of light; rather, one senses movement, particularly a flow of clear air over the figure.

11. *Reading*

1868 Oil on canvas 61 × 74 cm Louvre, Paris

This was painted in approximately the same period as *The Balcony* but the technique here is different. The compositional balance of the painting is maintained through a contrast between the black of the far right and the white with its overtones of blue in the foreground.

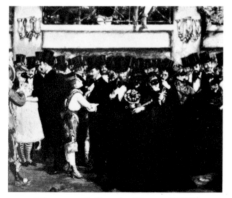

Manet, *Ball at the Opera* (1873)

12. *Masqued Ball at the Opera*

1873 Oil on canvas 47 × 38.5 cm Bridgestone Museum of Art, Tokyo

This experiment in supplying definition of form through coarse brush technique and color demonstrates a basic concept of impressionism.

13. *Lady with a Fan*

1874 Oil on canvas 100 × 153 cm Louvre, Paris

The model is Madame Nina de Caille, who maintained a salon in her home from 1868 to 1884. The background Japanese tapestries and fans produce an exotic, decorative effect.

14. *Portrait of Monsieur Brun*

1879 Oil on canvas 206.5 × 127 cm Bridgestone Museum of Art, Tokyo

Manet became influenced by impressionism around 1873, as can be seen in the pointillist techniques used to diffuse sunshine in foliage and shadows slanting across roads.

15. *Argenteuil*

1874 Oil on canvas 147.1 × 113.2 cm Musée des Beaux-Arts, Tournai

The golden rays of the sun seep through the distant greenery, the river, the flagpole, and illuminate the faces and the clothing of the foreground figures. This picture was actually painted at Petit Gennevilliers, not at Argenteuil.

16. *Bust of a Nude Woman*

1880 Pastel 53.5 × 46.5 cm Louvre, Paris

This portrait reveals the striking effect Manet could achieve with an astonishing economy of line and color.

17. *Garden Corner at Bellevue*

1880 Oil on canvas 54 × 65.8 cm Private Collection, Paris

In 1879 Manet began to suffer from rheumatism, and from June to September the following year he took a water cure at Bellevue. This scene is the garden of his rented villa.

18. *The Suicide*

1881 Oil on canvas 36 × 45 cm Bührle Collection, Zürich

This painting is another experimental advance in the blending of subject, color, and technique to create a mood and, in addition, a total aesthetic effect.

19. *Carnations and Vine in a Crystal Vase*

1882 Oil on canvas 56 × 35.5 cm Louvre, Paris

Manet was drawn to still life and particularly skilled in execution, as this captivating example attests.

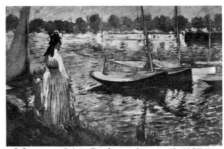

Manet, *Seine Banks at Argenteuil* (1874)

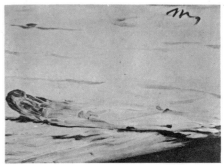

Manet, *Asparagus* (1880)

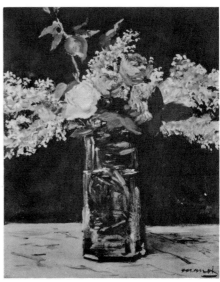

Manet, *Roses and Lilacs* (1883)

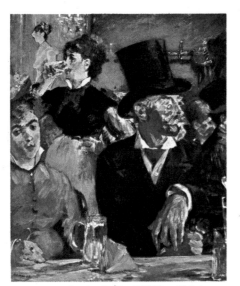

Manet, *At the Café* (1878). Shining blue and gold tints accent the monochromatic tones of the derby hat and dark clothing in this vivid portrayal of people relaxing.

Manet, *La Maison de Rueil* (1882). Manet was granted the Legion of Honor in 1881; the distinction came almost too late.

20. *The Café*

> 1878 Oil on canvas 78 × 84 cm Oscar Reinhardt Collection, Winterthur, Switzerland

After studying with the impressionists the effects of outdoor light, Manet returned to studio work. His genre paintings have a compelling realism. Cézanne's and Giacometti's works are similar in spatial arrangement to those Manet compositions that focus on a central subject while features to the right and left recede, lending perspective to the work.

21. *The Barmaid of the Folies-Bergère Bar*

> 1881 Pastel 55 × 43 cm Musée des Beaux-Arts, Dijon

The Folies-Bergère, now a famous institution of Paris, was at that time not internationally known. The contrast between light and dark is reminiscent of earlier portraits (Plate Nos. 7 and 11), but because of Manet's now advanced skill, there is greater lightness and freedom of touch.

22. *The Bar at the Folies-Bergère*

> 1882 Oil on canvas 95.3 × 129.6 cm Samuel Courtauld Collection, London

The large mirror behind the barmaid reflects the distant noise and mood of a music hall at night. At the right we see her reversed image together with that of an interested patron looking past the counter and bottles. This painting, an achievement of great imagination, employs consummate skill in the combination of perspective and subject to convey detail, mood, and extraordinary spatial depth.

23. *Corner of the Garden at Rueil*

> 1882–83 Oil on canvas 61.5 × 50.5 cm Musée des Beaux-Arts, Dijon

Manet rented a villa at Versailles in 1881, then moved to Rueil the following summer. His illness had worsened and he could barely walk. A somewhat hollow, absent mood pervades the landscape. He died in April 1883.

Manet, *Bullfight* (1865)

Monet, *Self-Portrait* (1917)

Claude Monet (1840–1926)

24. *The Road from Chailly to Fontainebleau*

1865 Private Collection

Each summer from 1863 on, Monet, Bazille, and other friends visited Chailly in Fontainebleau, only a short distance from that mecca of all landscape artists, Barbizon. Scenes of this kind are not really typical of Monet, for he usually painted seascapes at Le Havre and Honfleur. Just as atypical are the tight draftsmanship and attention to detail. The view does not flow, but seems to bend like a fabric covering in a framework of foliage. A sky bright with sunshine, swaying masses of greenery, and the straightness of the road all reveal the influence of Corot and Courbet.

25. *Garden in Bloom*

Circa 1866 Oil on canvas 65 × 54 cm Louvre, Paris

The greater freedom in technique indicates the artist's changing concept of painting and foreshadows his future style.

26. *At the Seaside*

1867 Oil on canvas 74.9 × 101 cm Art Institute, Chicago

The influence of Manet's palette and rhythm are evident in this painting. Colors are bright; yet contrast lies in the blacks, whites, and grays. The geometric perspective reminds us of Boudin, Monet's discoverer and first teacher.

27. *Women in the Garden*

1866–67 Oil on canvas 225.4 × 204.3 cm Louvre, Paris

In 1863 Monet saw Manet's *Le Déjeuner sur l'Herbe* at the Salon des Refusés. He considered painting a more realistic,

open-air, life-size work on the same theme. Two years later he began one part of the painting at Chailly, but it was only a large rough sketch, not destined to be completed. He started afresh at Ville d'Avray in 1866. He used no traditional techniques to emphasize a figure or costume, but concentrated mainly on the effects of sunlight.

Monet, *Le Déjeuner sur l'Herbe* (1866). Inspiration for this work came from Manet, but Monet's treatment of figures and light differs greatly from Manet's.

28. *Portrait of Madame Monet*

Circa 1871　Oil on canvas　48 × 75 cm　Louvre, Paris

The warm light entering the white-curtained window pervades the room. The dark blue of Madame's dress, the garnet of the book cover and neckerchief, and the white of the collar are colors that also harmonize in the wall, carpet and and rose-patterned couch. Monet married Camille Doncieux in 1870, and she was frequently his model. While indicating an appreciation of ambient light, this work bespeaks the artist's obvious admiration of his wife.

29. *Portrait of Madame Gaudibert*

1868　Oil on canvas　217 × 138.5 cm　Louvre, Paris

In September 1868 Monet thought of committing suicide because of financial difficulties. His admirer at Le Havre, Gaudibert, gave him assistance and commissioned him to paint a portrait of his wife. This beautiful and vivid painting, superb in its realization of texture, is the result.

30. *Pleasure Boats*

Circa 1873　Oil on canvas　49 × 65 cm　Louvre, Paris

Having spent his childhood at the port of Le Havre, Monet retained a love of water all his life. As a painter inclined to realism, he saw the surface of the water not as simply a mirror, but as a light prism, a retina of the earth, where color and vision are mixed.

31. *Impression, Sunrise*

1872　Oil on canvas　49.9 × 64.8 cm　Marmottan Museum of Art, Paris

This picture was displayed at an exhibition of independent artists in 1874, and it is from its title that the word "impres-

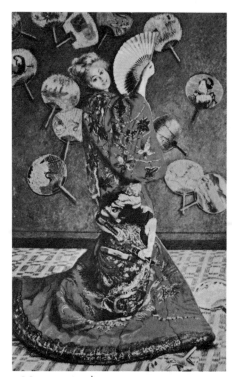

Monet, *Camille in a Japanese Dress* (1876). Japanese art was in vogue in France at this time. Camille appears a little bizarre in a Japanese kimono.

sionism" was coined. The skill with which the artist captures the seemingly impossible—the orange kiss of the sun, the dark looming outlines of the fishermen in their boats, the fresh morning mist, the surface hardness of the sea—supports the conceptual intention and the poetic beauty of this work.

32. *Yachts, Regatta at Argenteuil*

1874 Oil on canvas 60.1 × 86.1 cm Louvre, Paris

From 1872 to 1878 Monet lived at Argenteuil on the Seine and conducted a study of the relationship between light and objects. Clouds moving in various directions and the ceaseless cresting of waves became a fascinating challenge and spurred him to develop the divided-brushstroke technique.

33. *The Train in the Snow*

1875 Oil on canvas 68.9 × 80.1 cm Marmottan Museum of Art, Paris

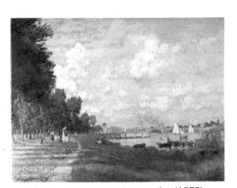

Monet, *Pond at Argenteuil* (1875)

Various nuances of white and dark gray define the atmosphere: engine smoke lofting into the air; conspicuously white snow waiting for the day's thaw; hardened, trodden snow; a sky of doubtful intention; a shivering line of defoliated trees; a stockade fence. All tones merge; yet all compete for survival at the expense of each other.

34. *Railway Bridge at Argenteuil*

1875 Oil on canvas 60.4 × 98.5 cm Philadelphia Museum of Art

This is another study of the same period at Argenteuil. The base of scattered clouds is moving quickly and the surface of the water is rippled. The smoke from the train engine mingles subtly with the clouds. The weather for this picture appears to have been fine and calm, as indicated by the bright sky and river. Close observation reveals spatial depth and the entire theme radiates an energetic life.

35. *Old Saint-Lazare Station*

1877 Oil on canvas 82.6 × 101 cm Art Institute, Chicago

Monet showed a series of Gare Saint-Lazare works at the third Group Exhibition in 1877. He was clearly delighted with

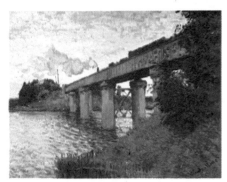

Monet, *Railway Bridge at Argenteuil* (*Circa* 1873)

the challenge of the interior and exterior light, the sense of motion of both people and machines, and the fading blend of motion and light in the distance.

36. *The Needle Arch at Etretat*

1890 Oil on canvas Private Collection, Paris

This brooding yet vivid painting combines the essence of impressionistic technique with Monet's deep kinship with the sea.

37. *The Seine at Vétheuil*

1879 Oil on canvas 60 × 81 cm Louvre, Paris

Monet left Argenteuil for the little village of Vétheuil, located between Paris and Rouen. This vibrant scene depicts the effects of light and breeze after rain.

38. *Rue Montorgueil Decked with Flags*

1878 Oil on canvas 61.6 × 33 cm Musée des Beaux-Arts, Rouen

As Monet himself recalled, he was walking down the Rue Montorgueil carrying his painting equipment on Bastille Day. Seeing the crowded street decked with flags, he climbed the stairs of an adjacent house and obtained permission to use the balcony. His rapid brushwork created a new technique in its dynamic conveyance of visual emotion. Each figure is individualized by a touch almost as personal as in calligraphy. This is possibly one of the first paintings to use a throng of people as its central theme.

39. *The Sea at Etretat*

1883 Oil on canvas 66 × 81.3 cm Louvre, Paris

Monet was at home by the sea and was fascinated by the ambient light. From 1883 on, he often visited Etretat. Against the changing sky he painted many aspects of the strange rock formation shown here. The sea's endless vista, its sheer size, and the fear it so often inspires are all revealed in this painting.

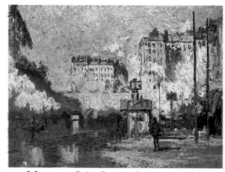

Monet, *Saint-Lazare Station* (1878)

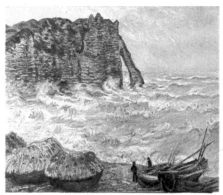

Monet, *Etretat* (1883)

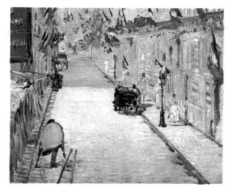

Manet, *The Rue Mosnier Decked Out with Flags* (1878). Just as Monet painted *Rue Montorgueil Decked with Flags* (1878), so Manet painted a similar bright scene.

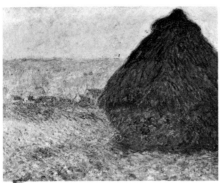

Monet, *Haystacks at Sunset* (1891)

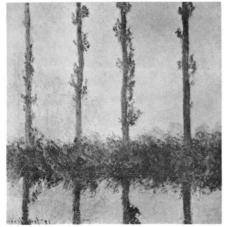

Monet, *Poplars* (1891)

40. *Haystacks, End of Summer*

1891 Oil on canvas 60.1 × 100 cm Private Collection, Paris

From autumn of 1891 throughout the winter of the following year Monet painted his series *Haystacks*, thirty of which survive today. In the ever-changing light and climate, he studied and observed the progressive changes of his subject. In this compelling series, he was capturing more than objects in place and light; he was embracing time on canvas.

41. *Woman with an Umbrella*

1886 Oil on canvas 131.1 × 88 cm Louvre, Paris

During his period of concentration on the elements of light, Monet painted no portraits. The model here is his daughter by his second wife. He did several paintings of this subject, and it is evident his concentration is on light and wind, not an identifiable human figure.

42. *Rouen Cathedral*

1894 Oil on canvas 100 × 65 cm Louvre, Paris

43. *Rouen Cathedral*

1894 Oil on canvas 91 × 63 cm Louvre, Paris

44. *Rouen Cathedral*

1894 Oil on canvas 106 × 73 cm Louvre, Paris

45. *Rouen Cathedral*

1894 Oil on canvas 107 × 73 cm Louvre, Paris

Monet started to paint an extensive Rouen Cathedral series in the spring of 1892. He continued it in the early spring of 1893 and worked throughout that year and most of the following year to complete the many paintings in this series. He had studied the effect of light on haystacks, poplars, water, and nature in general, and now he made a concentrated effort to express the dramatic result of the sun's rays on the old, precisely constructed cathedral. He examined the effects of the blue early-morning mist, the noon sunshine, and the evening glow of orange and blue on his subject. The structure of the

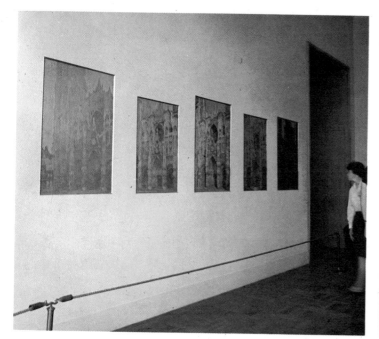

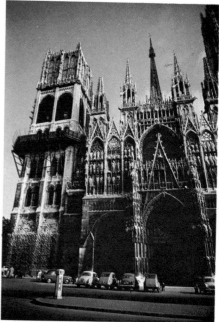

cathedral can be analyzed in the impingement and permeation of light. Both a conglomeration of hues vying for existence and the strength of their diffusion are revealed through a refined, mixed touch. The subject changes in appearance from turbid to mellow. Stronger than the sky and the thrusting perpendicular Gothic structure is the overwhelming anthem of light.

(left) Interior of art gallery showing Monet's Rouen Cathedral series
(right) Rouen Cathedral

46. *Venice, the Contarini Palace*

1908 Oil on canvas

In 1908 Monet first visited Venice, the city of water so many artists of the past have painted. Despite the magnificent architecture, it was the light that fascinated him.

47. *Westminster Bridge*

1900 Oil on canvas

From 1900 to 1904 Monet did a series of pictures of the River Thames, all of them with fog.

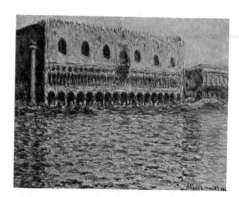

Monet, *The Ducal Palace at Venice* (1908). Monet was more concerned with the play of light and shadow on water than with the late Gothic architecture.

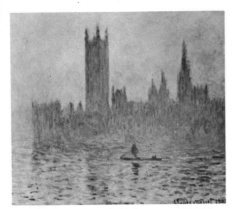

Monet, *London Parliament* (1903). Monet painted this work after he had visited London in 1899.

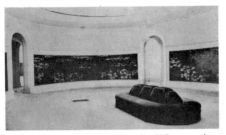

Interior of the Musée de l'Orangerie showing Monet's *Water Lilies*.

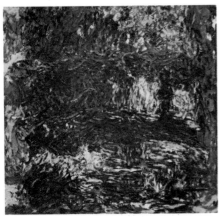

Monet, *The Drum Bridge* (1922)

48. *The Parliament of London*

1904 Oil on canvas Durand-Ruel Collection, Paris

As the fog reduces the Parliament building to a silhouette, so does Monet immerse himself in a world of magic. In this painting reality is treated as illusion, and the phantasmal is given prominence.

49. *Water Lilies*

Oil on canvas

50. *Water Lilies*

Oil on canvas

Monet made a pond in the garden of his Giverny house, filled it with water from a tributary of the River Epte, surrounded it with bamboo and willow trees, and floated various types of water lilies on its surface. By eliminating horizon and working in the mirror world of water reflection, he attempted innovations. Despite being handicapped by an eye cataract, Monet was encouraged by Clemenceau and painted a series of water lilies on oblong canvases in 1911. Here the pond has become an aquarium of flowers set on canvas by an artist whose sense of vision enabled him to capture brilliantly the lilies in bloom.

51. *Glycines*

Oil on canvas

52. *Iris Reflected in Yellow*

1922

Monet almost went blind in 1922; the following year he underwent surgery and partially recovered his sight. The flower paintings of his last year of life have a universal appeal to the spirit. They are magnificent, symphonic poems.

Edgar Degas (1834–1917)

53. Amateurs' Race, before the Start

1862 Oil on canvas 48.5 × 61 cm Louvre, Paris

During a vacation in 1860–61 near a race track, Degas became fascinated by scenes of horses and jockeys, subjects he continued to paint all his life. This early painting does not indicate his anatomical studies of movement, which became so brilliantly evident in later work.

54. Portrait of Thérèse Degas, Duchess Morbilli

1863 Oil on canvas 89 × 67 cm Louvre, Paris

Degas concentrated on portraiture from 1860 to 1870. His lines are sharp and angular, and a distinctive, elegant individuality is already noticeable. The model was his older sister Thérèse. In seeking a psychological portrait, Degas paid only scant attention to clothing and surroundings. An almost iconlike stillness prevails.

55. Portrait of a Young Woman

1867 Oil on canvas 27 × 22 cm

In contrast to the stark, etched line of *Thérèse Degas*, this work conveys the freshness and intensity of the unidentified young woman through subtle, warm-toned color gradations.

56. The Cotton Exchange in New Orleans

1873 Oil on canvas 74 × 92.1 cm Musée Municipal, Pau

In 1872 Degas traveled to the United States to meet his two brothers in New Orleans. This was the only painting he brought home and the first work purchased by a museum

111

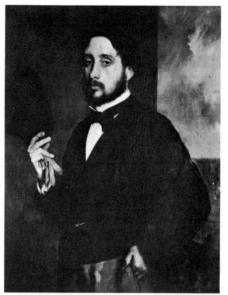

Degas, *Self-Portrait* (1862)

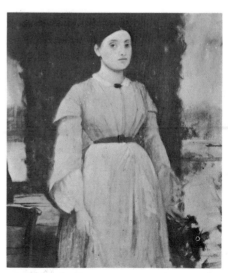

Degas, *Portrait of a Woman* (*Circa* 1861). The influence of Ingres is evident in the naturalistic technique of this work.

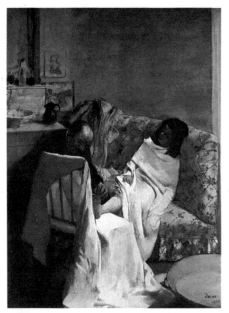

Degas, *Treating a Patient's Toe* (1873)

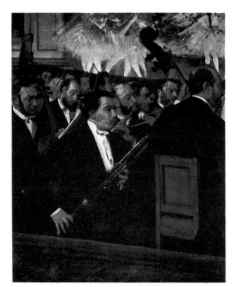

Degas, *The Opera Orchestra* (*Circa* 1868). Degas enjoyed painting scenes of ballet and the theater. This shows his friends, the bassoonist and cellist.

during his lifetime. To capture the rapid movement of the Cotton Exchange employees, Degas concentrated on perspective and individual pose, and ordered the figures into a unified composition, using only a few traditional, dark colors.

57. *Three Dancers*

1873 Oil on canvas 27 × 22 cm Private Collection, Paris

From childhood Degas was fond of opera. A bassoon player of the opera company became his friend and introduced him to other members of the same company. Since these contacts enabled him to frequent the backstage area, he began painting the ballerinas. The moving figures, co-ordinated in rhythm, established themselves as a main theme throughout his life, complementing his race horses and bathing women. He sketched each pose and later worked out a final interpretation by synthesizing his studies.

58. *Dancing Class*

1874 Oil on canvas 85 × 75 cm Louvre, Paris

Degas's association with the impressionists and his exposure to their discoveries of new formulas of light led him to acquire liberal coloring techniques; his pictures took on a flowerlike brightness. Here we see a pale-green wall, a yellowish-brown floor in delicate tones, white gossamer costumes, and ribbons of red, yellow, and green co-ordinated through the graceful, symmetrical use of black. There are three distinct groups of dancers, and the instructor with his cane is the central figure. The middle group receives instruction; the inactivity of the other two groups provides balanced contrast. Degas's signature is on a watering can at bottom left.

59. *Absinthe*

1876 Oil on canvas 92.1 × 68.2 cm Louvre, Paris

This work employs a contradictory scheme of balance and imbalance. The inspiration for depicting two morose people seated before glasses of absinthe obviously came from Zola's novel *L'Assommoir*.

60. *The Café-Concert, Les Ambassadeurs*

1876–77 Pastel on monotype 37 × 27 cm Musée de Lyon

Degas painted artificial lighting with rare sensitivity. Note the globular gas lamps against the glow of the sunset sky, the bright illumination at the entertainers' backs, and the dim lighting of the audience. Paris had many cafés like this one. Painted from a combination of the artist's mental impressions, this work accurately shows one aspect of the life of the times.

61. *Women at a Café: Evening*

1877 Pastel 40 × 60 cm Louvre, Paris

Degas loved the evening hours. Fearing that his eyesight would deteriorate, he preferred to walk about Paris after dark. He would later set down his impressions in his studio. In this bold painting the scene is dominated by three pillars, which, together with the curving lines of the chairs and human figures, provide a kinetic balance.

62. *A Dancer with Bouquet, Taking a Bow*

1877 Pastel 75 × 78 cm Louvre, Paris

Degas gradually turned to pastels in his work because he felt that the nature of the pigment suited his desire to emphasize color with line.

63. *Portrait of Duranty*

1879 Glasgow Art Gallery

Japanese woodblock prints influenced Degas, and he relinquished his familiar perspective for a new style. In this painting, the writer and critic Louis Edmond Duranty dominates despite the bright counter, with its piles of books, and the bookcase behind. With two fingers at his temple and his right arm resting on a book, the model's head is high enough to gain a central position in the subdued light. The painting is said to have been an exact likeness.

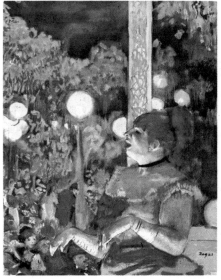

Degas, *The Dog Song* (1875–77). The woman is singing a popular song of the time, her face illuminated by stage footlights. This painting vividly expresses a gay nocturnal atmosphere.

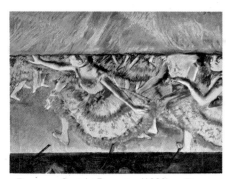

Degas, *Curtain Descent* (1880). Degas has captured the motion of the dancers, wonderfully expressed with a somewhat hurried touch and rich, glowing colors.

64. *Portrait of Diego Martelli*

1879 Oil on canvas 110 × 100 cm National Gallery of Scotland, Edinburgh

As in No. 63, Degas viewed his model from a position of height and added an angle of depression to exaggerate the sitter's obesity. The desk is painted in reverse perspective, as are the scattered papers. This style of spatial arrangement is often seen in Japanese woodblocks and picture scrolls. The model was a sculptor born in Italy.

65. *The Dance Foyer at the Opera, Rue le Peletier*

1872 Oil on canvas 32 × 46 cm Louvre, Paris

Appearing long after Degas's other paintings on the dance, this work seems to be out of sequence. Gray and ocher tones are highlighted by patches of scarlet and dark blue, while the glowing bodies and silken costumes are set in a melodious harmony of white. In this painting, depth and space are in traditional perspective.

66. *The Rehearsal*

1879 Oil on canvas 66 × 100 cm City Museum and Art Gallery, Glasgow

This work features a group of practicing dancers, one seated dancer, another having her costume adjusted by an attendant, and a spiral staircase concealing all but the legs and elbow of a third. Degas catches moments of movement and stillness. The carefully measured room is arranged so well it could be divided into self-contained sections. The movement flows from left to right, finally checked by the instructor's red shirt and the attendant's bonnet.

67. *Race Horses*

Circa 1878–80 Oil on canvas 40 × 89 cm Bührle Collection, Zürich

Degas studied photographs to record accurately the movement of horses. Compared with his earlier paintings, these

Suzuki Harunobu, *A Chrysanthemum* (1765–70). Harunobu (1725–1770) was a master woodblock-print artist. He was active for only five years but produced many imaginative and poetic color prints.

114

studies of horses are full of vitality and more impressive for the new relationship between form and space. There is a noticeably stronger indication of movement.

68. *Dancers in the Wings*

 Circa 1878–80 Pastel 28.9 × 26 cm Private Collection, Paris

69. *The Milliner*

 Circa 1882 Oil on canvas 99 × 109 cm Art Institute, Chicago

Here we view Degas's continual effort to impart movement to a composition by combining unusual shapes and figures in an unexpected manner. This painting is dominated by the motion of the salesgirl fastening a hat with a pin.

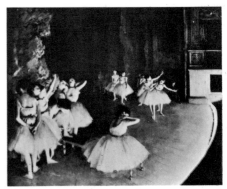

Degas, *Rehearsal on the Stage* (1871)

70. *Woman in the Bath*

 Toronto Art Gallery

Degas nudes are either in the middle of or at the end of a movement. The viewer's eyes can examine the nude starting from either the top right, where the woman is shown pouring water, or from the lower part of the canvas. Movement is directed by the relationship between what is immediately seen and subsidiary focal points.

71. *Café-Concert*

 1885 Pastel 26.5 × 29.5 cm Louvre, Paris

This work also has Japanese woodblock arrangement and dimensions.

72. *Woman Drying Herself*

In his late period Degas painted a series of nudes bathing, washing, drying themselves, and combing or having their hair combed. Degas's nudes are neither sensual nor passionate. Through a keen sense of vision he captured the instant of their motion, just as he had with his earlier horses and dancers.

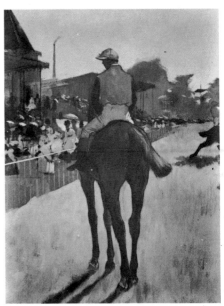

Degas, *Jockey before the Grandstand*, detail (1869–72)

73. *Dancers Ascending a Staircase*

Circa 1886–90 Oil on canvas 39 × 89.5 cm Louvre, Paris

A dancer caught mid-step in the center of the canvas mounts a flight of stairs while another dancer, her back toward us, descends the same stairs. A group dances in the background. The light and dark sections of a long wall are shown in re-

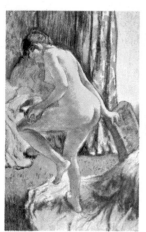

Degas, *The Bath* (1883)

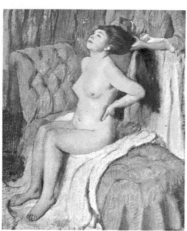

Degas, *The Hairbrushing* (*Circa* 1885)

Degas, *Lady's Hat Shop* (*Circa* 1883)

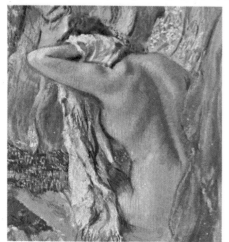

Degas, *After the Bath* (1885)

flected light. The arrangement is designed to suggest movement and, through it, dimension. The means of suggesting motion is similar to that of a motion picture; yet here, because the motion is confined to the theme of the picture, it continues endlessly.

74. *Dancers in the Foyer*

1889 Oil on canvas 42 × 92 cm Bührle Collection, Zürich

Degas here moves still further away from detail in his effort to catch the purity of movement and its rhythm. With only a limited use of black for outline, he employs panels of color and achieves action and life.

116

75. *After the Bath, Woman Drying Her Feet*

1886 Pastel on cardboard 54.3 × 52.4 cm Louvre, Paris

Degas was an admirer of women as subjects for art. Attracted by their beauty and femininity, he continued throughout his life to portray the female form nude and in motion. Here he has given grace to a posture that might have appeared ungainly in less skillful hands.

76. *Dancers in Blue*

1890 Oil on canvas 85 × 75.5 cm Louvre, Paris

Figure arrangement and the distribution of light and shadow combine to create an impression of movement and activity; a sense of motion determines the spatial composition.

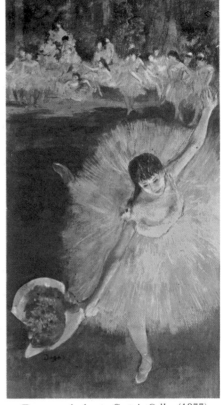

Degas, *Arabesque Curtain Call* (1877)

117

CHRONOLOGY

Manet / Monet / Degas	Date	General
Manet born January 23, Paris.	1832	Delacroix travels to Morocco.
Degas born January 19, Paris.	1834	Ingres makes second trip to Italy.
Monet born January 19, Paris.	1840	Rodin born in Paris.
Monet family moves to Le Havre. Degas sent to Lycée Louis le Grand.	1845	Poe publishes "The Raven."
Manet fails entrance examination to Naval Training School. Goes to sea as apprentice aboard transport ship and sails to Rio de Janeiro.	1848	The February revolution. Establishment of Second Republic. Gauguin born in Paris.
Manet enters Couture's studio in Paris. Studies there six years.	1850	Courbet exhibits *Burial at Ornans* at Salon.
Degas makes first visit to Naples.	1854	Van Gogh born 1853.
Degas enters art school, meets Bonheur.	1855	Paris World Exposition.
Manet makes short trip to Holland, Germany, and Italy. Monet does caricatures in Le Havre. Degas travels to Italy and stays in Rome, Naples, and Florence.	1856	Courbet produces *Girls on the Banks of the Seine*. In 1857 Baudelaire publishes *Les Fleurs du Mal*.
Monet meets Boudin, paints outdoors at Le Havre. Degas travels to Italy again and tours Florence, Perugia, and Assisi.	1858	Segantini born.
Monet studies at Académie Suisse, Paris. Meets Pissarro.	1859	Seurat born. Millet paints *The Angelus*.
Degas reveals interest in historic paintings under influence of Ingres and Italian masters. Monet departs for military service in Algeria.	1860	Large-scale exhibition of modern paintings opened by Delacroix, Corot, Courbet, and Millet.
Manet exhibits *Portrait of Monsieur and Madame Auguste Manet* at Salon.	1861	Bourdelle and Maillol born.
Monet granted medical discharge and returns to Le Havre to live with parents. During summer he works at Sainte-Adresse with Boudin. Returns to Paris in November and enters Gleyre's studio. Degas starts to paint race horses.	1862	Courbet and Corot meet at Saint-Anjou and work together.
Manet exhibits *Le Déjeuner sur l'Herbe* at Salon des Refusés. Provokes much criticism.	1863	Delacroix dies.
Manet exhibits *Olympia* at Salon and creates scandal. In August he travels to Spain, returns to France in October. He becomes leader of coterie of avant-garde artists gathering at Café Guerbois in Paris. Degas painting many portraits.	1865	Troyon dies.

		
Manet's *The Fifer* rejected by Salon. Monet paints *Women in the Garden*. His mistress Camille is model. Paints at Le Havre in autumn.	1866	Kandinsky born. Corot and Daubigny elected members of Salon Selection Committee.
Manet builds pavilion at World's Fair at personal expense and exhibits his old works.	1867	Baudelaire and Ingres die.
Monet works at Etretat and contemplates suicide because of poverty.	1868	
Monet and Renoir each paint version of *La Grenouillère*.	1869	Matisse born.
Manet and Degas serve in Franco-Prussian War. Monet takes refuge in London.	1870	Franco-Prussian War breaks out. Paris under seige from autumn throughout winter.
Thirty Manet canvases bought by art dealer Durand-Ruel. Monet travels to Holland and on return settles in Argenteuil. Argenteuil period begins.	1871	Paris Commune established in March.
Manet travels to Holland. Degas begins to paint backstage at opera company. In fall travels to the U.S., stays in New Orleans. Returns home April 1873.	1872	Mondrian born.
First Group Exhibition held at Nadar's studio in April. Monet, Degas, Cézanne, Renoir, Pissarro, and Sisley exhibit. The critic Leroy mockingly coins the word "impressionist" from a Monet painting entitled *Impression, Sunrise*. Manet refuses to participate in exhibition.	1874	Renoir paints *A Box Seat*. Cézanne produces *Modern Olympia*.
Manet exhibits works in own studio. Cézanne introduces Monet to the collector Chocquet. Monet begins *Gare Saint-Lazare* series.	1876	Corot and Millet die 1875. Third Republic established. Second Group Exhibition held.
Manet helps Monet rent house in Vétheuil. Monet's Vétheuil period begins.	1878	Daubigny dies. In 1879 the Third Group Exhibition held.
Manet granted *hors-concours* at Salon and exhibits freely despite jury's opinions. Receives Legion of Honor. Degas submits sculptures of dancers and other subjects to Sixth Group Exhibition.	1881	Picasso and Léger born. Sixth Group Exhibition held.
Manet's rheumatism makes walking increasingly difficult.	1882	Braque born.
Manet's left leg amputated. He dies April 30. Monet moves to Giverny to begin third period of his work. He travels to Riviera and discovers new light quality in southern France.	1883	Utrillo born. Monet one-man show at Durand-Ruel Gallery.
Degas begins nude studies. His eyes begin to trouble him.	1885	Van Gogh paints *The Potato Eaters*.
From winter Monet works in Antibes on the Riviera. In June travels to London.	1888	Gauguin and Van Gogh share living quarters.
Monet begins series on poplars and haystacks.	1890	Van Gogh dies.

Degas's worsening eyesight hinders his work. Monet stays in Rouen throughout February and March, painting series on Rouen Cathedral.	1893	Miró born. Matisse and Rouault meet at Moreau's studio.
Monet builds pond in garden at Giverny house and starts series of paintings on water lilies. Visits London in fall and paints series on River Thames.	1899	Nabi exhibition at Durand-Ruel Gallery. Sisley dies.
Monet visits Venice and paints landscape series.	1908	Picasso exhibits works of his African period.
Monet begins new water-lily series.	1910	Rousseau dies.
Encouraged by Clemenceau, Monet begins large decorative panels of water lilies and continues work until 1916.	1914	World War I begins.
Degas dies September 27.	1917	Rodin dies.
Monet almost totally blind with cataracts in both eyes.	1922	Rouault begins painting *Guerre et*
Operation partially restores Monet's sight and he resumes painting water-lily panels in l'Orangerie Museum.	1923	*Miserere.*
Monet dies in Giverny on December 5.	1926	Ernst publishes his naturalist magazine.

LIST OF COLOR PLATES

Édouard Manet 1832–1883

1 *Portrait of Monsieur and Madame Auguste Manet* 1860 Private Collection, Paris
2 *Le Déjeuner sur l'Herbe (Luncheon on the Grass)* 1863 Louvre, Paris
3 *Olympia* 1863 Louvre, Paris
4 *The Fifer* 1866 Louvre, Paris
5 *The Execution of Emperor Maximilian* 1867 National Museum of Art, Mannheim
6 *Portrait of Émile Zola* 1868 Louvre, Paris
7 *The Balcony* Circa 1868–69 Louvre, Paris
8 *Port of Boulogne by Moonlight* 1869 Louvre, Paris
9 *The Departure of the Folkestone Boat* 1869 Oscar Reinhardt Collection, Winterthur, Switzerland
10 *On the Balcony of Columns at Oloron* 1871 Bührle Collection, Zürich
11 *Reading* 1868 Louvre, Paris
12 *Masqued Ball at the Opera* 1873 Bridgestone Museum of Art, Tokyo
13 *Lady with a Fan* 1874 Louvre, Paris
14 *Portrait of Monsieur Brun* 1879 Bridgestone Museum of Art, Tokyo
15 *Argenteuil* 1874 Musée des Beaux-Arts, Tournai
16 *Bust of a Nude Woman* 1880 Louvre, Paris
17 *Garden Corner at Bellevue* 1880 Private Collection, Paris
18 *The Suicide* 1881 Bührle Collection, Zürich
19 *Carnations and Vine in a Crystal Vase* 1882 Louvre, Paris
20 *The Café* 1878 Oscar Reinhardt Collection, Winterthur, Switzerland
21 *The Barmaid of the Folies-Bergère Bar* 1881 Musée des Beaux-Arts, Dijon
22 *The Bar at the Folies-Bergère* 1882 Samuel Courtauld Collection, London
23 *Corner of the Garden at Rueil* 1882–83 Musée des Beaux-Arts, Dijon

Claude Monet 1840–1926

24 *The Road from Chailly to Fontainebleau* 1865 Private Collection
25 *Garden in Bloom* Circa 1866 Louvre, Paris
26 *At the Seaside* 1867 Art Institute, Chicago
27 *Women in the Garden* 1866–67 Louvre, Paris
28 *Portrait of Madame Monet* Circa 1871 Louvre, Paris
29 *Portrait of Madame Gaudibert* 1868 Louvre, Paris
30 *Pleasure Boats* Circa 1873 Louvre, Paris
31 *Impression, Sunrise* 1872 Marmottan Museum of Art, Paris
32 *Yachts, Regatta at Argenteuil* 1874 Louvre, Paris
33 *The Train in the Snow* 1875 Marmottan Museum of Art, Paris
34 *Railway Bridge at Argenteuil* 1875 Philadelphia Museum of Art
35 *Old Saint-Lazare Station* 1877 Art Institute, Chicago
36 *The Needle Arch at Etretat* 1890 Private Collection, Paris
37 *The Seine at Vétheuil* 1879 Louvre, Paris
38 *Rue Montorgueil Decked with Flags* 1878 Musée des Beaux-Arts, Rouen
39 *The Sea at Etretat* 1883 Louvre, Paris
40 *Haystacks, End of Summer* 1891 Private Collection, Paris
41 *Woman with an Umbrella* 1886 Louvre, Paris
42 *Rouen Cathedral* 1894 Louvre, Paris
43 *Rouen Cathedral* 1894 Louvre, Paris
44 *Rouen Cathedral* 1894 Louvre, Paris
45 *Rouen Cathedral* 1894 Louvre, Paris
46 *Venice, the Contarini Palace* 1908

47 *Westminster Bridge* 1900
48 *The Parliament of London* 1904 Durand-Ruel Collection, Paris
49 *Water Lilies*
50 *Water Lilies*
51 *Glycines*
52 *Iris Reflected in Yellow* 1922

Edgar Degas 1834–1917

53 *Amateurs' Race, before the Start* 1862 Louvre, Paris
54 *Portrait of Thérèse Degas, Duchess Morbilli* 1863 Louvre, Paris
55 *Portrait of a Young Woman* 1867
56 *The Cotton Exchange in New Orleans* 1873 Musée Municipal, Pau
57 *Three Dancers* 1873 Private Collection, Paris
58 *Dancing Class* 1874 Louvre, Paris
59 *Absinthe* 1876 Louvre, Paris
60 *The Café-Concert, Les Ambassadeurs* 1876–77 Musée de Lyon
61 *Women at a Café: Evening* 1877 Louvre, Paris

62 *A Dancer with Bouquet, Taking a Bow* 1877 Louvre, Paris
63 *Portrait of Duranty* 1879 Glasgow Art Gallery
64 *Portrait of Diego Martelli* 1879 National Gallery of Scotland, Edinburgh
65 *The Dance Foyer at the Opera, Rue le Peletier* 1872 Louvre, Paris
66 *The Rehearsal* 1879 City Museum and Art Gallery, Glasgow
67 *Race Horses* Circa 1878–80 Bührle Collection, Zürich
68 *Dancers in the Wings* Circa 1878–80 Private Collection, Paris
69 *The Milliner* Circa 1882 Art Institute, Chicago
70 *Woman in the Bath* Toronto Art Gallery
71 *Café-Concert* 1885 Louvre, Paris
72 *Woman Drying Herself*
73 *Dancers Ascending a Staircase* Circa 1886–90 Louvre, Paris
74 *Dancers in the Foyer* 1889 Bührle Collection, Zürich
75 *After the Bath, Woman Drying Her Feet* 1886 Louvre, Paris
76 *Dancers in Blue* 1890 Louvre, Paris

LIST OF ILLUSTRATIONS

Page

82 Ingres *Madame Inez Moitessier* 1851

82 Corot *Recollection of Pierrefonds*

83 Manet *Christ with Angels* 1864

83 Degas *A Dancer Holding a Tambourine*

84 Paris World's International Exhibition of 1867

84 Boudin *Brussels Canal* 1871

84 Jongkind *Landscape with Windmill*

85 Manet *Concert at the Tuileries* 1860

86 Manet *The Urbino Venus* 1856

86 Manet *The Old Musician* 1862

86 Manet *The Spanish Ballet* 1862

87 Goya *Milkmaid at Bordeaux* 1827

87 Manet *The Execution of Emperor Maximilian*

88 Manet *Portrait of Stéphane Mallarmé* 1876

88 Manet *Lunch in the Studio* 1868–69

89 Velàzquez *An Old Lady Cooking Eggs* 1617–22

89 Monet *Camille with a Puppy* 1866

90 Monet *Terrace near Le Havre* 1866

90 Monet *The Bridge at Argenteuil* 1874

90 Monet *Vétheuil: Effect of the Snow* 1878

91 Monet *Floating Ice* 1880

91 Monet *Monet Painting the Floating Studio* 1874

91 Monet *Spring* 1874

92 Seurat *Posing Women* 1888

92 Monet *Poplars* 1891

93 Degas *The Bellelli Family* *Circa* 1860–62

93 Degas *The Rehearsal* 1873

94 Degas *Two Laundresses* 1876–78

94 Degas *Laundresses* *Circa* 1884

95 Degas *Fourteen-Year-Old Dancer* 1874–81

95 Degas *Study of a Race Horse*

96 Degas *Woman Putting on Corset*

97 Manet *Self-Portrait with Palette* 1879

97 Giorgione *Fête Champêtre* 1510

97 Marcantonio *The Judgment of Paris*

98 Titian *Venus of Urbino* 1538

98 Goya *The Naked Maja* 1798–99

98 Velàzquez *Lady with a Fan* 1644–48

99 Goya *The Shooting of May 3, 1814*

99 Goya *Majas on a Balcony* *Circa* 1796

100 Manet *The Departure of the Folkestone Boat* 1869

100 Manet *Ball at the Opera* 1873

101 Manet *The Seine Banks at Argenteuil* 1874

101 Manet *Asparagus* 1880

101 Manet *Roses and Lilacs* 1883

102 Manet *At the Café* 1878

102 Manet *La Maison de Rueil* 1882

103 Manet *Bullfight* 1865

104 Monet *Self-Portrait* 1917

105 Monet *Le Déjeuner sur l'Herbe* 1866

105 Monet *Camille in a Japanese Dress* 1876

106 Monet *Pond at Argenteuil* 1875

106 Monet *Railway Bridge at Argenteuil* *Circa* 1873

107 Monet *Saint-Lazare Station* 1878

107 Monet *Etretat* 1883

107 Manet *The Rue Mosnier Decked Out with Flags* 1878

108 Monet *Haystacks at Sunset* 1891

108 Monet *Poplars* 1891

109 Interior of art gallery

109 Rouen Cathedral

109 Monet *The Ducal Palace at Venice* 1908

110 Monet *London Parliament* 1903

110 Interior of the Musée de l'Orangerie

110 Monet *The Drum Bridge* 1922

111 Degas *Self-Portrait* 1862

111 Degas *Portrait of a Woman* *Circa* 1861

112 Degas *Treating a Patient's Toe* 1873

112 Degas *The Opera Orchestra* *Circa* 1868

113 Degas *The Dog Song* 1875–77

113 Degas *Curtain Descent* 1880

114 Suzuki Harunobu *A Chrysanthemum* 1765–70

115 Degas *Rehearsal on the Stage* 1871

115 Degas *Jockey before the Grandstand* 1869–72

116 Degas *The Bath* 1883

116 Degas *The Hairbrushing Circa* 1885

116 Degas *Lady's Hat Shop Circa* 1883

116 Degas *After the Bath* 1885

117 Degas *Arabesque Curtain Call* 1877

Slip case:
 Front *Le Déjeuner Sur l'Herbe* Manet 1863
 Back *Water Lilies* Monet 1907

Front Cover:
 The Tub Degas 1886